DIGITAL
PHOTOGRAPHY
FOR CHILDREN'S AND
FAMILY PORTRAITURE

SECOND EDITION

KATHLEEN HAWKINS

AMHERST MEDIA, INC. ■ BUFFALO, NY

All photos as attributed in captions, except:
page 112—photo of Frank Donnino by Dick Robertson
page 113—photo of Sherri Ebert by Rick Ferro
page 115—photo of Jeff Hawkins by Kathleen Hawkins
page 116—photo of Joann Muñoz by Mario Muñoz Jr.
page 117—photo of Craig Minielly by Robert Gilbert
page 118—photo of Vicki Popwell by Robert Evers
page 119—photo of Vicki and Jed Taufer by Bert Behnke
page 120—photo of Jennifer George by Darton Drake

Front cover photo by Vicki and Jed Taufer.
Back cover photo by Jeff Hawkins.

Published by:
Amherst Media, Inc.
P.O. Box 586
Buffalo, N.Y. 14226
Fax: 716-874-4508
www.AmherstMedia.com

Publisher: Craig Alesse
Senior Editor/Production Manager: Michelle Perkins
Assistant Editor: Barbara A. Lynch-Johnt
Editorial Assistant: Artie Vanderpool
Editorial Assistant: Carey Maines

ISBN-13: 978-1-58428-214-3
Library of Congress Control Number: 2007926862
Printed in Korea.
10 9 8 7 6 5 4 3 2 1

Contents

Photo by Vicki and Jed Taufer.

Photo by Jennifer George.

About the Author

Photo by Jeff Hawkins.

Kathleen Hawkins is an advisor to photographers across the country. She and her husband, Jeff Hawkins, own and operate an award-winning children's and family portrait studio in Orlando, Florida.

Kathleen is the author of several books: *The Bride's Guide to Wedding Photography, The Parent's Guide to Photographing Children and Families,* and *Marketing & Selling Techniques for Digital Portrait Photographers,* all available from Amherst Media. Together with her husband Jeff, she is the co-author of *Professional Marketing & Selling Techniques for Wedding Photographers* (2nd ed.) and *Professional Techniques for Digital Wedding Photography* (2nd ed.), both from Amherst Media.

Kathleen is a member of Wedding and Portrait Photographers International (WPPI) and Professional Photographers of America (PPA). In addition to overseeing the operation of their photography studio, Hawkins is a marketing and sales consultant for photographers nationwide. She conducts private consultations and leads workshops at photography conventions worldwide, educating photographers on the products and services that create a successful business for their clients. Industry sponsored, she is very active in the photography lecture circuit and takes pride in her impact on the industry and community.

SPECIAL THANKS

A special thanks to all of the contributors to this book. Each of you has provided much valuable information and guidance, and you have truly inspired photographers everywhere.

Jeff Hawkins, my wonderful husband, blessed me with his love and then with the love of our two beautiful daughters. He is a wonderful creative photographer, husband, and father.

Dan Chuparkoff, computer guru and friend, is there for me whenever I need help, no matter how much or little time I give him!

Frank Donnino reminds me that no matter how much experience or education one may have, there is always a person who can open your eyes to

something you could do bigger or better. He is a marketing guru whom I admire.

Sherri Ebert probably doesn't realize the effect her work has had on me, and I am certain her work has been equally significant to her clients. As someone who loves children, I appreciate how Sherri's portraits depict children from an intimate perspective that brings the images to life. She helped me take our portraits to a different level, capturing more than just a pose or an expression, capturing the life!

Craig Minielly changed our studio with his custom Photoshop actions! He is a truly talented photographer and an innovator in the photographic industry, and his actions rock!

Joann Muñoz gave me the confidence to be more than an office manager and a wife in a family-operated studio, but now a photographer and a mother of two. She proves the philosophy that no matter how long you have been doing something or how hard a change can be, with family, anything can be accomplished.

Vicki Popwell opened my eyes to the world of children's photography and taught me to appreciate it and cherish it as the gift it truly is!

Vicki and Jed Taufer showed us how to see through each of our subject's eyes and into their souls. Their work is inspiring, and their cheerful personality is contagious to those around them.

Jennifer George is so full of passion and deeper than any woman I have ever met. The weekend we spent at the women's photography retreat was profound, and the wisdom and passion she puts into her art is admirable. She motivated me to make a difference with the images we create.

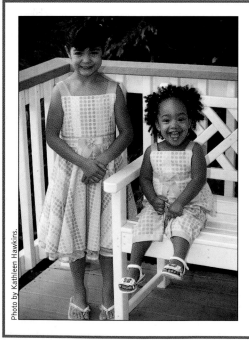

Photo by Kathleen Hawkins.

DEDICATION

This book is dedicated to the two children I love the most. My beautiful daughters Michelle and Rachel, I couldn't imagine a day without you in my life. I am so glad to have met you and to be blessed enough to be your mom. Remember, though you didn't grow under my heart, you grew in it! I look forward to taking thousands of images of you both in the years to come.

Introduction

Do you remember when a photo session was only about creating a powerful image? In our travels to various studios throughout the country, we have visited many photographers—some using film, some digital. As times change, so does the industry. Who would have imagined that in making the transition to digital, we would be faced with increased copyright infringement issues or would create images for clients who know more about photo manipulation software than we do?

To be competitive in this market, you need to delve into all of the artistic opportunities at your fingertips. Photo by Vicki Popwell.

Based on data from the U.S. Census Bureau, most new parents today range in age from twenty-five to thirty-five. People in this age bracket have been using computers for many years now. Their children will most likely be computer savvy before they reach high school. As you can imagine, these clients are looking for professional photographers who can offer all of those top-notch images that the digital revolution has made possible. To be at the top, you need to create the quality work your clients expect using the available technology.

This book will show you how to integrate the newest digital technologies to significantly enhance your children's and family portraiture. Together, we will analyze the philosophy required to make this change and explore the benefits that the changing technologies offer. We will also unravel the steps and systems necessary to implement the newest technology and build an effective digital workflow.

For the experienced photographers already using today's technology, this book will explore an alternative workflow system and reemphasize the importance of organizational systems. It will also offer marketing suggestions and business techniques from industry leaders across the country.

1. Philosophy

Successful portrait photography is about more than new equipment and raw talent. It is about analyzing your competition, establishing your market, and offering a unique, in-demand product. Digital technology allows you to create unique portraits that are perfectly geared toward your intended market while maintaining control over your work. It also gives you the ability to effectively utilize blogging, online marketing, and much more.

Digital technology allows you to create unique portraits that are perfectly geared toward your intended market while maintaining control over your work. Photo by Frank Donnino.

Digital technology allows you to create images that satisfy your artistic vision. Photo by Jeff Hawkins.

With this technology and the right mind-set, anything is possible for your portrait business! Once you accept the digital challenge, you'll need to stay ahead of the curve to stay on top professionally. To plot that course, you'll first need to analyze the changes in the industry.

INDUSTRY CHANGES
Using advanced technology changes the way you do business. It allows you to create images you never dreamed possible. It also requires that you do

Well-coordinated clothing helps viewers to focus on the relationships between the subjects in group portraits. Photos by Craig Minielly.

things differently. A discussion of some of the most significant adjustments follows.

Retouching. In the days of shooting film, you probably sent your images out for retouching or just sat back and hoped your client would accept the image just as it was shot. Digital imaging makes in-house retouching possible, thus providing photographers with more creative freedom than traditional film photography. Clients are well aware of this. When they notice things such as oily skin, exit signs in the background, and threads on their clothing in their cherished images, they will view the work as inferior.

Copyright Infringements. Once upon a time, paper proofs were the industry standard for image presentation. However, these proofs were costly to

A great image need not be full of expensive props. All you need is your subject and a great portrait concept. Above photo by Vicki and Jed Taufer. Right photo by Jeff Hawkins.

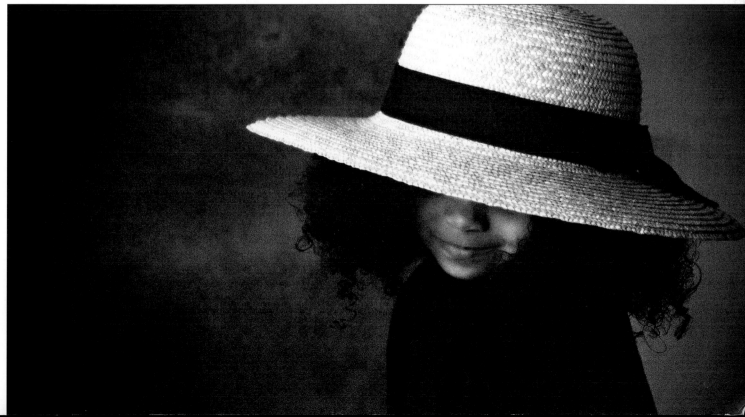

produce, and many clients kept these inferior prints, never placing an order. Photographing your clients digitally will allow you to quickly and easily upload digital files and imprint each image with a watermark that discourages the client from copying the images. Though film images can be scanned and viewed online as well, it is a time-consuming alternative.

Some enterprising clients will stop at nothing to get their images. In my travels, I recently met with a photographer who actually had a client copy proofs with a small consumer-type digital camera while sitting at his studio. In another studio, a subject's mother took digital images over the photogra-

Portrait panels (top) are just one product that can be easily produced when you're working with image editing software. Corel Painter is a popular software choice for adding a painterly effect to portraits (bottom). Photos by Vicki Popwell.

Jack & Drew

WATERMARKS

A watermark is a digital code that, while imperceptible in your photograph, proves authorship of your image. At our studio, we use Photoshop to create watermarks for stock or advertising photos, as this method does not affect the quality of the photograph. With stock and advertising photos, the watermark is typically placed in the lower right-hand corner of the image or along the side of the photograph. We tend to use a phrase like "image by www.jeffhawkins.com" or our studio logo so that viewers know who created the image and labs know the image is copyrighted.

When it comes to proofing, we rely upon WnSoft's PicturestoExe (www.wnsoft.com). This program allows the client to see the image without the watermark in the middle of the photograph. The executable file prevents copying, printing, or any other right-click capability of the mouse.

With online ordering, the watermark (e.g., a low-resolution image of your logo) is placed in the middle of the image to prevent the illegal reproduction of the image. Most online services set up a feature where the watermarking takes no additional time and is automatically part of the uploading process.

To be at the top, you need to create the quality work your clients expect using the available technology. Photo by Frank Donnino.

pher's shoulder during the portrait session. This problem is clearly here to stay! Consider implementing the following proactive measures to help eliminate these occurrences as often as possible:

- Post a sign in your shooting area or in the waiting area that reads, "No Consumer Photography Allowed."
- Have every client sign a contract containing the clause "Simultaneous photographic coverage by another photographer, professional or consumer, shall release John Doe Studio from this agreement. Should such an event occur, the professional fee will be retained. In addition, we request that guests or family members not take pictures of our setup or posed shots, as doing so will delay the photographic process and impact or ruin the resulting photographs. John Doe Studios owns all negatives, digital files, and photographs. We retain the rights to reproduction of any images produced in connection with this agreement. The reproduction of any photograph in any form is hereby prohibited and protected under Federal copyright laws and will be enforced to the fullest extent allowable by law."

Be sure to take the necessary precautions to protect your images against unauthorized use. Photo by Jeff Hawkins.

Proactive Solutions. Technology is ever changing. To ensure that you'll succeed as a photographer, you'll need to put systems in place to implement consistent, cost-effective retouching; modify your proofing structure to make ordering easy for your clients; and implement the above-mentioned practices to discourage unauthorized and unscrupulous client practices.

On the other hand, you can continue doing business as is, hoping that consumers appreciate your quality of work enough to not steal your images.

FEAR AND PROCRASTINATION

The fact that you chose this book implies that you are ready to embrace the new possibilities technology offers to improve your portraiture. Take a moment to think about the fears you have felt in the past about making changes.

AN UNEXPECTED ALTERNATIVE
Today, a growing number of clients have flatbed scanners and an ability to easily copy and reproduce your images. To protect themselves, many photographers are modifying their pricing structures and including low- (or even high-) resolution image files with a portrait session. This allows the client to produce copies with your permission, thus pleasing the client and padding your profit line.

YOUR LOGO

Yourtown Photography
111 Main Street
Yourtown, FL 11111
(555)555-5554, (800)555-5555
www.yourwebsite.com
e-mail: photographer@yourstudio.com

PORTRAIT PHOTOGRAPHY CONTRACT

Membership selected: _____ Enrollment date: _____ Date: _____

PERSONAL INFORMATION

Name: _____ Spouse: _____

Primary address: _____

City: _____ State: _____ Zip: _____

Home phone: _____ Work phone: _____

Alternate phone: _____ E-mail: _____

Occupation: _____ DOB: _____ Occupation: _____ DOB: _____

Children's names: _____ Age: _____

_____ Age: _____

_____ Age: _____

PRODUCT INTERESTS

Albums: _____ Style: _____

Frame sizes: 30x40____ 20x24____ 16x20____ 11x14____ 8x10____

Desk-art gifts: 10x10____ 8x8____ 8x10____ 5x7____ 5x5____ 4x6____

Notes: _____

PAYMENT REQUIRED

$_____ Total charges

$_____ Additions

$_____ Sales tax

$_____ Total due

$_____ Nonrefundable retainer

Date paid: _____

$_____ Balance due

Date paid: _____

Client: _____

Date: _____

DESCRIPTION OF SERVICES

This agreement, entered into on _____ is between Yourtown Photography, in the State of Florida and doing business as John Doe Photography, and the undersigned (hereinafter referred to as "Client") relating to the portrait session of _____.

_____ (init.) SERVICE COVERAGE: The parties agree that Yourtown Photography will furnish the services of a professional photographer. John Doe and a trained assistant (if needed) will provide photographic coverage services. The fee for item/membership is $_____. Simultaneous photographic coverage by another person or contracted photographer shall release John Doe from this agreement and the professional/membership fee will be retained. In addition, we request that guests or family members NOT take pictures of our setup/posed images; doing so may delay the process and effect or ruin the outcome of your photographs. We cannot guarantee any specific photograph or pose. We will, however, attempt to honor special requests.

_____ (init.) PAYMENT POLICY and EXPENSES: A fee of $_____ is placed as a retainer herewith to purchase referenced services. This fee is nonrefundable, but may reapplied (subject to availability) if the session is rescheduled. All purchases will be paid by the Client at the time the order is placed. If the final purchase price exceeds what was paid, the new balance must be paid before production can begin. The selection of the portrait album photographs must begin within two weeks of viewing the previews or the album design layout. With respect to Product Credits, credits and applicable products not used/ordered within six months of receiving the video will be forfeited.

Contractual modifications to this agreement may be subject to a $150.00 service charge.

_____ (init.) PORTRAIT OF A LIFETIME PROGRAM: Program length available for the duration of the client's life or the life of Yourtown Photography, whichever is greater or in such an event that the business is dissolved. Time and locations subject to availability and determined at the discretion of Yourtown Photography. Based on the type of session and the amount of people being photographed and the location desired, a minimum product purchase may be required. Portrait sessions not used will be forfeited. Program membership is nonrefundable and nontransferable. Sessions based upon availability.

_____ (init.) BABY PLAN MEMBERSHIP GUIDELINES: Plan includes eight sessions and one color/unretouched 8x10-inch print from each session. Sessions must be used within five years from the contract date or the remaining sessions will be forfeited. The 8x10-inch print must be selected from each separate session and cannot be combined. Each session includes one location, one outfit, and one prop and must be used by one child. Additional portrait subjects will incur a separate session fee. All dates, times, and locations are subject to availability and at the discretion of Yourtown Photography. Portrait Program Plan special offer is nonrefundable and nontransferable.

_____ (init.) DESIGNER ART BOOKS PROGRAM PACKAGE: Designer Art Book product credit is nonrefundable but may be applied to a product purchase. Sessions will be broken down over a one-year period. The Book is required to go into production no later than eighteen months after the initial purchase date or the credit paid is forfeited.

Signature: _____

Date: _____

PORTRAIT PHOTOGRAPHY CONTRACT (pg. 3 of 3)

_____ (init.) PRODUCT PRICING: Pricing is defined on the attached price list. All prices quoted for professional services, photographs, and albums are valid for a period of two months following the date of the session. Orders placed after two months following the session are billed at the studio's currently published prices, which may be greater.

_____ (init.) LIMITATION of LIABILITY: While every reasonable effort will be made to produce and deliver out-standing photographs of the session, Yourtown Photography's entire liability to the Client for claim, loss or injury arising from John Doe's performance is limited to a refund to Client of the amount paid for services. Yourtown Photography cannot guarantee delivery of any specifically requested image(s). As mentioned above, if our services are canceled for any reason, the retainer paid to reserve the date is nonrefundable and the membership fee is forfeited. In the unlikely event of personal illness or other circumstances beyond the control of John Doe, a substitute photographer of high qualifications, subject to the acceptance by Client prior to the event, may be dispatched by John Doe to fulfill the obligations of photography herein contracted. In such case that the Client declines John Doe's sending of a substitute photographer, the Client may elect instead to reschedule the appointment. NO refund will be given if the client elects cancellation of the Portrait of a Lifetime Program. In the event there is a dispute under this contract, the parties agree that the loser will pay the winner reasonable attorneys' fees. The venue shall reside in Seminole County, Florida.

_____ (init.) FEDERAL COPYRIGHT LAWS: Yourtown Photography owns all original files, and unless specified, these are not part of any package. We retain the rights to reproduction of any images produced in connection with this agreement. Copying or reproduction of any photograph in any form, unless released, is hereby prohibited and protected under Federal Copyright Laws, and enforced to the full extent allowable by law.

_____ (init.) ALBUM ORDERS: Using special design techniques, Yourtown Photography will advise in the layout of the album(s), however, all choices by the Client will prevail. One design session is included with each album/book purchased. If the client requests an additional design session, a $250.00 fee will apply. To begin construction of the album(s) a deposit of half of the remaining balance is required. The balance will be due upon approval of the layout. In the event of a cancellation of a Designer Art Book, unused album credit can be applied toward a product credit based on the discretion of Yourtown Photography. Orders placed more than two months after previewing your images will be priced at the studio's currently published prices, which may be greater. Following the notification of completion of order, unpaid balances will be subject to a 2.5% monthly service charge. We are not responsible for albums left unclaimed after sixty days. Items not claimed and picked up after sixty days may be used for stock and studio display, and monies paid will be forfeited. Delivery of John Doe's hand-assembled album(s) ordinarily occurs within nine to twelve weeks after the receipt of the order. This time may vary based upon the size and style of the album(s).

_____ (init.) ORDERING REPRINTS: If we are to mail orders, appropriate shipping/handling and insurance fees will be charged. We are not liable for loss, damaged product, or mishandled packages. If images are lost or damaged, you must seek remedies from the carrier.

There are a total of three pages to this agreement. Please initial each item and sign where indicated.

Signature: _____

Date: _____

Why did you hesitate to move forward? Which technology or investment challenged you most? Are you procrastinating about making a change that will help to further your career? Why are you hesitant to move forward?

For many, the most limiting factors in making the switch to digital or increasing the usage of technology available to their business are fear and procrastination. In order to reduce the fear of change, you must be able to momentarily suspend judgment and step out of your comfort zone. You must be able to let go of your opinions long enough to consider another perspective. Rather than approaching digital with a "prove it to me" attitude, consider adopting a more inquisitive outlook. Ask yourself, What if this would work? What opportunities would be created? Once you begin thinking out of the box, new opportunities will be revealed. Not so long ago, my husband and I thought we would never offer complimentary portrait sessions or release a DVD of master files. After doing some careful research, we decided to

Think outside of the box to capture portraits your clients are sure to love. Photo by Frank Donnino.

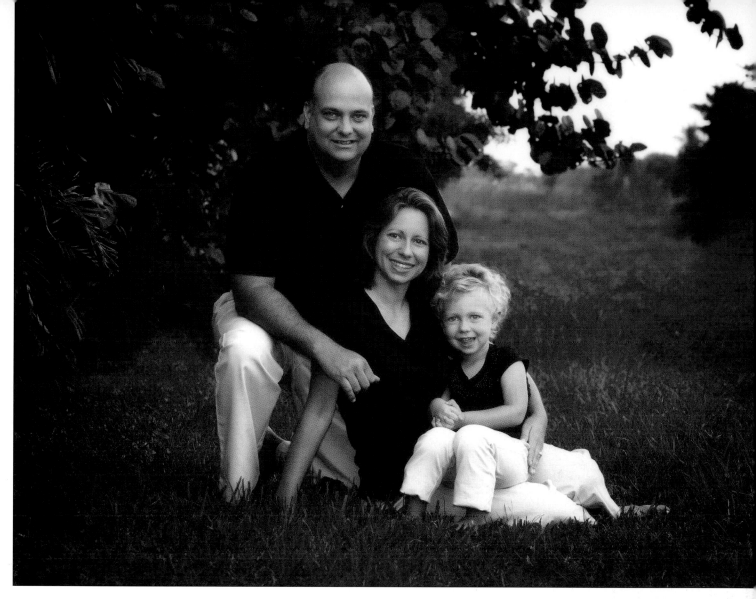

When creating images, be sure that your setup is not photographed over your shoulder by a client's guest or a family member on the set. Also, ensure that your clients are aware that it is illegal to reproduce your prints. Photo by Frank Donnino.

offer a gift-with-minimum-purchase promotion and a Lifetime Portrait promotion. They've turned out to be two of the most successful campaigns we have launched this past decade.

Commitment to Change. Around every bend lies a new challenge. Let's face it: things are changing quickly in this industry, and they're changing for the better. For this reason, when photographers get up to speed, they typically don't stay comfortable for long. When you make the switch to digital, you will be greeted by new opportunities. You have to commit to the change and establish clear goals and identify the strategies you'll need to reach them. Once you know what your goals are, it is easier to befriend your discomfort.

TECHNOPHOBIA

Human beings use procrastination as a means to avoid discomfort, and for some, a fear of machines and technology is the root of that discomfort. Many studios have not yet committed to using a computer system, although doing so would only contribute to their success.

If you find yourself in this situation, you should realize that using today's technology will help you achieve your artistic and financial goals. Together,

Don't overlook the possibility of photographing at outdoor locations. Using natural elements or architectural backdrops can allow you to create a diverse array of work not possible in your studio. Photos by Craig Minielly.

computers and digital technology make it easier to quickly process information and images, revise documents, and provide a more efficient and effective form of customer service for your clients. When you employ the available technologies, you can more readily embrace the possibilities for maximizing your photography.

Perhaps you have never used a computer before or are intimated by the endless possibilities that a program like Adobe Photoshop offers. Have confidence in yourself! When you used your first camera, you had to learn the basics to capture images with artistic flair. You learned what buttons to push, which lenses work for what type of images, and eventually different settings. The same applies to using new hardware or software: You do not need to understand the mechanics inside of your new equipment to use it effectively. You do not need to know where each wire leads and how the microchips work or how to repair your digital equipment. If something isn't working, send it off to the repair shop. Simply put, you do not need to be a computer programmer to operate a computer and to work with digital equipment. Many people learn how to turn on their computer, utilize their favorite programs or software, and then turn it off again. There are many computer experts available to help you combat any problems you might encounter along the way.

To embrace today's technology, you have to step out of your comfort zone, confront change, and work to learn new skills. This can be a lot to

With digital, you have the freedom to capture as many exposures as your heart desires, without concern about processing all of the images from the session. With this freedom, photographers can capture wonderful, photojournalistic images with natural expressions. Photo by Frank Donnino.

digest; with these hurdles, it is easy to see why many photographers suffer hesitation.

Of course, individuals choose new behaviors because they help them to achieve what they want most. What do you want for your business? Are you willing to let go of your fears and grow?

Above and facing page—When you achieve a certain comfort level with your clients and gain their trust, you can capture unforgettable expressions and depict the strong bond the family members share. Top and facing page photos by Vicki and Jed Taufer. Bottom photos by Jennifer George.

2. The Benefits

Making the switch from film to digital will require a financial investment. However, as more and more studios make the switch, the size of the investment will decrease. Also, going digital will allow you to improve your images and your production process; the cost of *not* investing will be more

Digital capture offers instant gratification. Photographers can see their images right away and can maintain control of their work in every stage of the image-making process. Photo by Vicki Popwell.

With digital imaging, you can perfect a photo to the full extent of your creative vision. Photo by Vicki and Jed Taufer.

substantial. Because the transition to digital is difficult, many studio owners give up on their goals and return their cameras. The fact of the matter is, many photographers become overwhelmed by a poorly managed workload.

Knowing these obstacles exist, why is it essential to convert your children's and family portraits into digital images?

There are a great number of payoffs that you'll realize once you've made the transition to digital. We'll look at a number of the pluses in this chapter.

INSTANT GRATIFICATION

One indisputable advantage is that digital capture offers instant gratification. With digital, photographers can see their images right away and can maintain control of their work in every stage of the image-making process—from capture to output.

INCREASED ARTISTIC CONTROL

Photographers who shoot digitally are no longer capturing the portrait session in twelve or twenty-four exposures and releasing their images to the lab for processing. With digital imaging software, we can now perfect our images

With digital imaging software, we can perfect our images to the fullest extent of our imagination. Left photo by Vicki and Jed Taufer. Above photo by Vicki Popwell.

to the fullest extent of our imagination—we can control cropping; make color corrections; correct common problems like low-light situations, bad angles, unwanted people and props; and eliminate blemishes, scars, or other perceived imperfections. Digital offers us the opportunity to swap one expression for a better one captured in another image, and that's an incredible advantage. The fact that digital technology allows us to make duplicate copies of any image without spending a fortune on custom retouching has changed children's and family portrait photography forever!

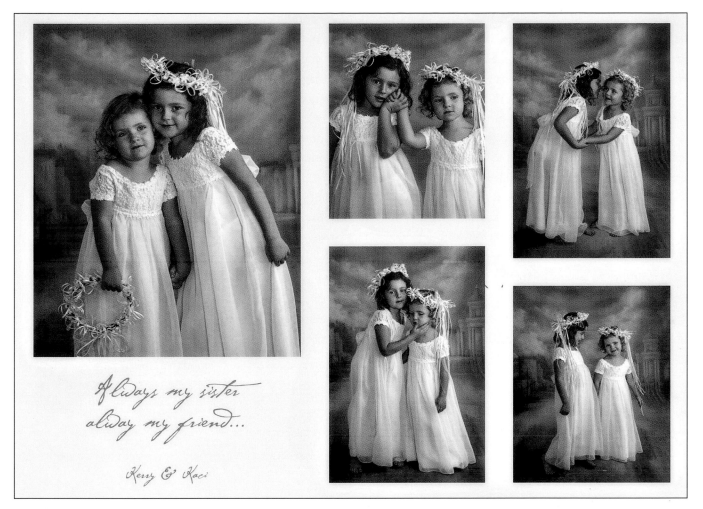

Always my sister
alway my friend...

Kerry & Kaci

![Open dialog box screenshot]

Top—Vicki Popwell's images of children are featured in local kids' clothing boutiques and in pediatrician's offices. This marketing strategy helps her to generate a great deal of interest in her work. **Above**—Digital technology allows you to organize your images more effectively so you can easily retrieve them to order new prints or create stock images and business displays.

ADVERTISING

Another advantage to today's technology is the ability to expand your advertising reach. You can easily e-mail newsletters, create a website filled with your best images, and even nurture your client relationships by sending special notes right from your computer. With digital capture, we have seen improvements in our vendor relationships (in stock advertising), community awareness (newsletters and gift certificate promotions), and customer service (with an expedited workflow and instant feedback).

Stock Images. Providing stock photography is a source of free advertising—an opportunity you should certainly take advantage of! With film photography, the photographer had to rummage through proofs, pull negatives, send them off to the lab, have prints made, hope they were perfect and didn't need any retouching, and then finally submit their stock images to the vendor. That required a substantial investment of time and energy. Producing stock photography is now faster, easier, more convenient, and less expensive than ever before. With digital technology, all you have to do is create stock photography folders on your computer, then copy images to the folders when prepping each client's file.

To get started, identify which businesses in your community could benefit from your photography. These businesses may include: family publications, model homes, doctors' offices, children's clothing boutiques, etc. If a vendor elects to display an image on their website, you can deliver the image to them on CD or DVD with copyright information. If the vendor prefers to add the image to a sample album, you can create a print for them using either your printer or the services of a lab. As you get to know your area vendors, you will learn which method they prefer. Some may even request that your studio set up a display at their place of business.

Business Displays. When setting up a business display, devote the same careful attention you would to decorating your studio. Many photographers like to use old frames or images to spare added expense. Be sure to showcase your current work—don't sell clients on images that represent your studio's past! You should create an annual advertising budget that allows for custom-framed samples for your studio and business displays.

Photographer Vicki Popwell has had much success with her business displays. She says, "When asked to do a display of some of my favorite images in a pediatrician's new office, I said yes! I had several images of children on

Showcase your current work— don't sell clients on images that represent your studio's past!

Develop a relationship with local businesses and display your images in those stores or offices. Photos by Vicki Popwell.

Be sure to have a signed model release for any subject you are using in stock images or displays. Photo by Joann Muñoz.

Get a signed model release for any subject appearing in stock images or displays.

my desktop and had experimented with using different filters and painting techniques. I printed twenty large images in a soft black & white, making them look like charcoal paintings. I matted each image to match the office décor, using dark red, bright yellow, and celadon. Each hand-signed and matted image was placed in a black matte wood frame and personally hung for the physician. The entire cost of the display was around $600, most of which came from the mats, glass, and frames. The cost of each portrait was low since I was able to digitally output the images myself."

Vicki considers the cost of putting together such a display a marketing and advertising expense. She says, "Displays like this are a win/win situation for me and the physician involved. I gain the attention of many new clients, and the physician receives a wonderful, well-suited addition to his office décor at no cost to him."

Popwell also has a great display in a children's clothing store. She planned this exhibit to include fantasy images of children—dressed as fairies, ballerinas, and cowboys—as well as beautiful newborn babies and moms. "It was a lot of fun to experiment with the images and make each one look like a painting or art poster through Corel Painter and Adobe Photoshop," Popwell explains. (Get a signed model release for any subject appearing in stock images or displays. This is especially important when photographing children!)

Photo Credits. Regardless of the means by which you deliver your images, consider adding your website, studio logo, or signature to the lower corner

Left and above—Vicki Popwell's painterly images are a big hit with her clients. In addition to creating beautiful prints, she also features her images on watercolor note cards. A properly attributed quote was added at the bottom of this card. Note the photo credit on the right side of the image. **Facing page**—Digital imaging allows you to quickly and easily produce proofs and start the production process, regardless of whether you print the images in your studio or send them out to a lab. Top photo by Jennifer George. Bottom photo by Vicki and Jed Taufer.

of each portrait. (Using your web address as a photo credit offers a clear advantage: when an image catches a perspective client's eye, he or she has a means to get in touch with you.) Using a program like Adobe Photoshop or Corel Painter, you can customize your photo credit to suit various markets. Though using an address label may seem like an easy alternative, it detracts from the overall look of the portrait.

EXPEDITED WORKFLOW

It is never a bad idea to understand how to run every aspect of your business, but you should never take on too much responsibility yourself. Developing

a timeline like the one below can help keep you on task and speed up your workflow.

Sunday: Office closed.

Monday: Office closed.

Tuesday: Conduct session, save images, prep for proofing.

Wednesday: Place images online, conduct proofing sessions, order stock image prints from your lab.

Thursday: Conduct sessions, prep products for delivery.

Friday: Conduct sessions or design digital editorial-style albums such as Day in the Life or Treasured Moments montage albums.

Saturday: Conduct sessions as deemed appropriate.

Using our old film-based workflow, it took two weeks—and sometimes even longer—to have the images developed and processed. With the new digital system, the proofs can be ready for viewing as quickly as the studio wants to show them. Some studios prefer to show the proofs before clients leave the studio. Other photographers, like Jeff Hawkins, prefer to schedule a second appointment. He believes that a preview session in which the children are not present is less stressful and boosts sales. It also gives him adequate time to perfect the proofs and modify any images as desired. He states, "The clients will buy any image I take the time to modify. They love them every time!" However, it is important never to modify an image too fast or in front of a client. It may diminish the value of your masterpiece in your client's eyes.

The digital process allows clients to receive their final product within six to eight weeks from the date of their session—even the library-bound Montage Art digital books! This quick turnaround time is a great advantage to digital capture.

LOWER EXPENSES

After the initial equipment investment, switching to digital is a profitable venture! The money you save in film, processing, and proofing is substantial. By switching to digital, we reduced our average monthly overhead by more than $3,000. The only additional overhead you may incur is in shifted employee responsibilities. However, if this is carefully managed, you could save money here as well.

By using marketing software from www.marathonpress.com (Client Connection, Email Newsletter, and Marketing Partnership Software) and taking advantage of promotional software called Caffeine (www.caffeinenow.com), we were able to trim our publication budget from $3500 to $800 a month and draw a higher rate of return with much lower investment.

As you can see, with creative planning and financing, much of the equipment can actually pay for itself within the first few months.

Above—With digital, you can be sure that you got the images you need before your client even leaves the studio. Photo by Jeff Hawkins. **Facing page**—Album design is yet another creative outlet made easier with today's software options. Photos by Jeff Hawkins.

EDITORIAL ALBUMS

Some of the top digital photographers in the country follow a subject throughout his or her activities during a single day—from morning until night! Our Day in the Life album is a perennial favorite.

Many photographers also produce editorial-style albums that feature images taken over a span of time. These albums (called Treasured Moments montage albums at our studio) are popular with photographers who are chronicling a baby's first year, the activities of a kindergartner, or a high school senior's special moments.

7 months

9 months

God commanded the sun to rise and to set and still to us

our girls are the greatest miracles yet

1 year

3. Evaluating Equipment

Now that you have accepted the fact that using today's technology is vital to the success of your business, it is important to evaluate the basic tools required for staying afloat. How do you plan to prep and proof your images? What equipment will you need to modify your photographs? Evaluate your budget and create a marketing plan for your business. Keep in mind that making the transition may take more time than originally anticipated, so do not

Utilize all of the resources available to keep up with digital imaging trends and advancements. Photo by Jeff Hawkins.

Using the LCD of your digital camera to evaluate the images from a session can give you peace of mind, as you can quickly review your images to ensure you captured some great images of that on-the-go toddler you're photographing. With film, photographers had to wait until proofs came back to know whether any good images were captured during the shoot. Left photo by Frank Donnino. Right photo by Vicki and Jed Taufer.

count on film and processing savings to cover any additional expenses early in the game. Consider purchasing a less expensive camera to see how the digital workflow process feels, then step it up a notch as you gain confidence and experience. Never sacrifice quality just to save a few bucks, however. Remember, your reputation in the community is far more valuable than any savings purchasing a low-end camera might achieve. When first selecting digital equipment, ask to see other digital photographers' work and compare the results achieved with different equipment.

CAMERA SELECTION

The three most important factors in selecting camera equipment are features, specifications, and pricing. Because models and features are changing every day, it is beyond the scope of this book to recommend specific models or de-

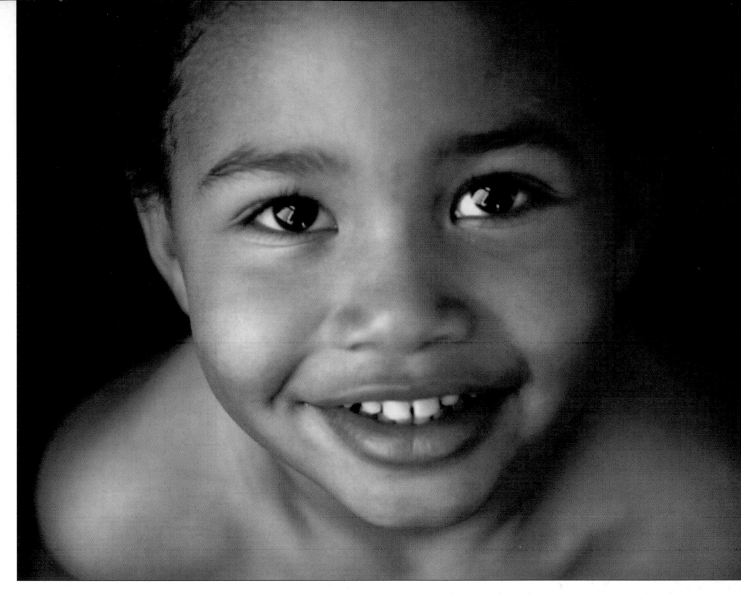

Facing page and above—Don't skimp when it comes to buying equipment. Your clients count on you to preserve their memories as best you can, and you owe it to them to produce an heirloom-quality image. Photos by Jennifer George.

tail their features. However, through research and communication with other photographers throughout the United States, I have found that the most popular cameras have common characteristics. These cameras offer features that make capturing images easier, accept your existing lenses to minimize the initial investment, and yield sharp, high-quality images.

CMOS and CCD Chips. First, let's explore the differences between CMOS and CCD chips. The CCD (charge-coupled device) or CMOS (complementary metal oxide semiconductor) is a small photosensitive semiconductor chip onto which light is focused in the digital camera. The CCD acts as the "film," converting the image it captures into pixels. Pixels can be defined as the smallest unit (a single dot) of information viewed on your computer screen. CCDs contain receptors (similar to exposure meter light sensors) that act as sampling points. The more receptors in the CCD, the higher the resolution and image quality will be. CCD chips are considered more sensitive than CMOS chips and typically offer greater image resolution. However, as with all technology, chips continue to improve every day.

CMOS chips serve the same function as CCDs. While they are less expensive to manufacture (which can often reduce the cost of the camera), they

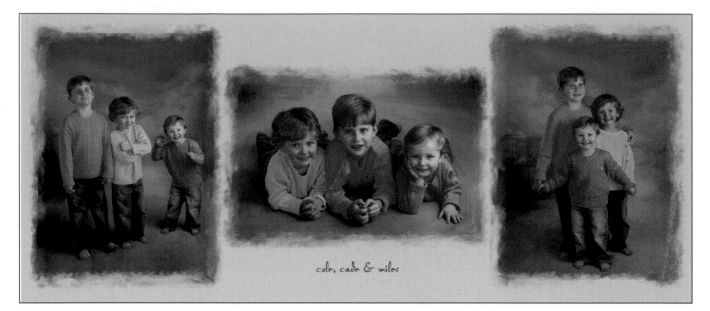

cole, cade & miles

can present problems with noise and tend to be less sensitive than CCDs. Nevertheless, they require less power than CCDs, allowing for lower battery consumption and fewer backup batteries than a CCD camera. Currently, a big advantage to some of the higher-end professional cameras with the CMOS chip is the ability to capture full-frame images and utilize the autorotation feature.

While manufacturers continue to perfect both chips and produce a higher-grade product, it is important to keep in mind that the size and quality of the CCD/CMOS will impact image quality and factors into the price of the camera. The CCD/CMOS size currently found in the most popular cameras is growing every day—and bigger is better!

Memory Cards. Images in a digital camera are stored in one of two ways: on a built-in, reusable memory device or on a removable memory device. If the images are stored on a built-in device, they can be transferred to your computer via a cable connection. Cameras with built-in memory are considerably less expensive but have many drawbacks. For instance, once the storage device in the camera is full you must empty it before additional images can be captured. In cameras with removable media, the camera writes the image data to the removable storage device as you capture your photographs. This is a much more versatile system; when the card becomes full, you can simply eject it and insert a new one, just as you would change film at the end of a roll. When you get back to your computer, the images can be transferred to your hard drive and the memory device can be reused.

Two common removable media card formats are Smart Media and CompactFlash cards. Currently, CompactFlash cards have higher maximum capacities and more sophisticated electronics that make them more versatile. The capacity and design of these cards have a great impact on the convenience of using the camera and the ease of transferring images to your computer. The

As photographer Vicki Popwell's images show, adding an artistic effect to your images with Corel Painter can help you achieve your creative vision.

cost will be determined by the durability and sensitivity of the cards, but both types have been used by many successful studios.

Card Readers. A card reader is a device that is used to read memory cards without connecting your camera to the computer. Some readers accept only one particular card format, while others accept multiple types.

Some computers and printers now also feature built-in card readers.

Burst Rate. The camera's ability to shoot and process images one after the other is referred to as its burst rate. The number of shots per second and the process rate varies from one camera to another. Professional cameras can burst ten frames per second for a maximum of 110 full-resolution JPEG images or 30 RAW images. The ability to work quickly is especially important when working with energetic children!

Sensitivity/ISO. A film with a low ISO is more effective in bright conditions; one with a high ISO is more sensitive and is therefore better in low light situations. In digital technology, the sensitivity is determined by the sensor (called the CCD/CMOS). One of the great advantages of digital technology is the ability to quickly alter the sensitivity at any time, meaning that you don't have to wait to change a roll of film before selecting a new ISO.

Often, the higher the ISO, the greater the amount of noise that will appear in the image. If you are conducting a portrait session in someone's home and are faced with a low-light situation, you should use a higher ISO—typically, 400–800. However, if you are outside in a bright-light situation, a lower ISO—typically 200 or less—would be sufficient.

Full-Frame Capture Capability. A camera equipped with a CMOS chip can capture a full-frame image. This "what you see is what you get" concept offers photographers a wider range of photographic possibilities.

Shutter Response Time. Shutter response time is often referred to as "lag" time. This is the length of time that lapses between when you press the button and when the camera fires. Professional digital cameras characteristically have an acceptable shutter response time, but this time will vary from model to model. The shutter response time will directly affect the camera's burst rate and the photographer's ability to work quickly.

LCD Panel. An LCD panel is used for immediate image analysis. Make sure that any camera you're considering has an LCD that is large enough and sharp enough to allow you to see the image clearly.

Lens Capability and Accessories. When shopping for lenses and accessories, ask yourself the following questions: Does the camera accept the type of lenses you want to use? Are the accessories you prefer available for it?

Color Depth/Bit Depth. The higher the bit depth, the greater the amount of color information available. The more color, the better the image.

When shooting in the RAW mode (uncompressed images) with a professional camera, you normally create a 16-bit image, which represents millions of colors. When photographing in JPEG Fine mode (compressed images),

The higher the bit depth, the greater the amount of color information available.

you typically create an 8-bit image, which may only represent several hundred colors. Both modes are effective, but a tremendous difference in color possibilities exists.

An LCD screen allows you to review your photos after the shoot to ensure you captured some great images. Above photo by Jennifer George. Facing page photo by Jeff Hawkins.

When shooting, it is best to photograph fewer images in RAW mode than numerous images in JPEG Fine mode, as RAW mode will provide a higher-quality image and allows for bigger, higher-quality enlargements.

Dimensions/Weight. As with any other camera, your digital camera should be one that you are comfortable carrying and shooting.

System Requirements. To take full advantage of the potential of digital imaging, it is important that your camera (or its storage devices) and your computer can communicate effectively.

Price versus Quality. When considering various camera brands, models, and capabilities, be sure to weigh quality and price. Remember, while you don't need to purchase a top-of-the-line camera, you should never sacrifice quality, as doing so may ruin your professional reputation.

CAMERA-RELATED SOFTWARE

Each camera has its own unique software that allows the photographer to see the image as it is taken and then make modifications as needed. Many camera manufacturers package their software with the camera. However, some

Once you're comfortable with using the latest technologies, you can take your creativity and technical proficiency to new heights. Photo by Jeff Hawkins.

companies do not, and the software may be an additional expense to factor into your budget.

COMPUTER EQUIPMENT

When selecting the computer equipment you will need to make the digital transition, consider consulting a computer professional or network administrator to help you with your needs. Keep in mind that your studio will likely benefit from having two or more computers networked together, and be sure to discuss this need with your mentor. The performance of the server, especially when doing a lot of digital imaging, is extremely important.

Some of the things to discuss with your programmer (or perhaps your photography mentor) in regards to your computer equipment include, but are not limited to, the following:

- Should you go Macintosh or PC?
- How much RAM, hard drive space, and processor speed are needed?
- What features do you need to run your software?
- Will you be able to upgrade the computer at a later date?
- What printers and modems will you need to purchase?
- Does it come with instructional materials? Will any training be available?
- Will a high-speed modem be required to work with larger image files?

Your studio will likely benefit from having two or more computers networked together.

When shopping for a computer, be sure to get one with the fastest processor and the highest amount of RAM you can afford. You may also want to purchase a removable hard drive or laptop with an S-video-out port for connection to a compatible TV or VCR. This is especially important if you plan to use your new technology for on-site displays at various locations. Many photographers use this technology for event photography such as family reunions, mis quince anos, and bat or bar mitzvahs.

COMPUTER ACCESSORIES

In addition to the computer itself, effective digital imaging requires a number of other components. These components include:

Monitor. A monitor is where you will view all your work and do any retouching or image modifications. We suggest using a twenty-inch or larger monitor with higher image resolution settings (as of this writing, 1200x1600 or 2560x1600 if you are running a dual-monitor system). The resolution is

If you're converting from film to digital, it may be wise to buy a camera that will accept lenses you already own. Photos by Jeff Hawkins.

the number of dots or pixels per inch that the monitor uses to display an image. A CRT monitor is recommended for photo imaging. It features a maximum resolution and a low dot pitch. When researching your options, keep in mind that a lower dot pitch is your best option.

CD/DVD Burners. A CD or DVD burner allows you to create CDs and DVDs easily, providing a convenient way to back up your work. When selecting a CD or DVD burner, consider whether your company will benefit from the use of rewritable CDs or DVDs. Will your clients be keeping their proofs? Will you send CD or DVD orders to the lab, and will the lab return the materials to you? Also consider whether your DVD can be played on both your client's computer and their DVD player.

Graphics Tablet. A graphics tablet is a pressure-sensitive pad and stylus that replaces the mouse. It is very useful for accurate photo enhancement and manipulation, since it offers increased control.

Other Accessories. There are countless other accessories that may prove valuable to you. For example, many studios also use a tape drive backup system and server to further protect their images. As your business grows, talk to your computer consultant for advice and suggestions.

A graphics tablet is a pressure-sensitive pad and stylus that replaces the mouse.

PHOTO MANIPULATION SOFTWARE

Photo manipulation software is designed to help you perfect your images and add creativity to your work. When working with digital technology, be certain to invest in the most recent manipulation software available, and purchase software upgrades as they become available.

Two of the most popular and effective programs of this type are Adobe Photoshop and Corel Painter. Photoshop offers a number of helpful tools that can be used to retouch or otherwise enhance your images and add special effects. For instance, the Healing Brush (introduced in Photoshop CS2), makes retouching efficient and effective, and the Auto Color feature pro-

Vicki Popwell used Corel Painter to transform this original image (left) into a watercolor masterpiece (right).

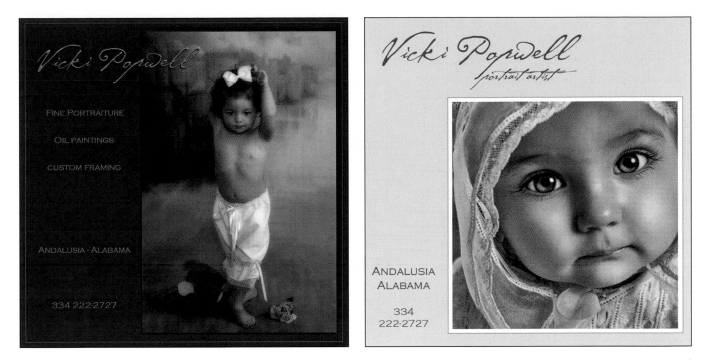

Top left and right—Photo manipulation software can be used for more than just image retouching. You can also use this software to design albums or marketing pieces. Photos by Vicki Popwell. **Above**—The Healing Brush tool in Photoshop makes retouching easy and effective.

duces automatic color corrections. Additionally, Bridge (a program packaged with Photoshop) allows you to view your image files and rank them in order of importance. This can save a studio a tremendous amount of time. Corel Painter allows users to easily apply painterly effects to their photographs, thereby expanding the creative options they can offer their clients.

There are many programs available for purchase, each of which can be used to manipulate your images in various ways. Apple Aperture and Adobe Lightroom can be used to process and present RAW image files. Genuine Fractals (available through HALLoGRAM Publishing) is designed to resize images. For color correction and to fix exposure problems, you can turn to iCorrect (available through Pictographics International Corporation) and Test Strip (available through Vivid Details).

Plug-ins. Plug-ins are special software programs that work in conjunction with image processing software, allowing you to quickly and easily add new dimension to your images. Color Efex Pro! and Sharpener Pro from Nik Software are especially valuable for photographers. Color Efex Pro! provides users with unique filter effects and allows photographers to selectively paint in color effects in specific areas of their images. Sharpener Pro provides additional tools for image sharpening. To enhance your images using borders and edge effects, try Auto FX's Photo/Graphic Edges software. John Hartman's QUICKMats can be used to create digital mats and liners for your images.

SALES PRESENTATION AND ORGANIZATIONAL SOFTWARE

To make the most of the digital experience, you need to develop a well-organized processing system. There are several programs available—all of which work in conjunction with Photoshop—that can be used to rotate, or-

ganize, number, and display images. Companies that routinely work with labs often rely on lab software and support to assist in the organizational process. Many studio owners who process their images in-house use Pro Select (www.timeexposure.com) or iView MediaPro (www.iview-multi media.com) software. Pro Select includes a browser and works as a slideshow creator, ordering system, proofing tool, montage (composite layout) designer, and a production system. iView MediaPro is a digital assets management and cataloging solution for creative professionals who handle large volumes of digital files, such as photographers, designers, and

ArtLeather's Montage ProVision can help you boost album sales.

artists. With iView MediaPro you can quickly and easily organize, catalog, edit, publish, annotate, and archive all your images, movies, fonts, and sounds.

Microsoft Windows XP Professional also offers features for organizing and displaying your images for easy access. Its built-in software allows you to make copies of your files or photos directly onto CD-R or CD-RW. It has been used to expedite and organize the digital workflow of many studios.

ALBUM PRODUCTION SOFTWARE

ArtLeather's Montage ProVision is a great program designed to increase album sales by assisting with the album design process. However, many studios prefer the TDA software by Albums Australia. The program includes hundreds of templates that can be resized or edited to suit any format you wish. With this program, you can create unique and beautiful album pages or portrait collages in a matter of minutes, not hours—no Photoshop experience required! It's easy to learn and simple to use: just import your images, select a template or create your own, and drag your photos into each aperture.

It is important to identify your studio's needs and shop around before buying a printer.

PRINTERS

It is important to identify your studio's needs and shop around before buying a printer. You can determine your printing needs by first deciding whether you will be printing your clients' images or sending the majority of your files to the lab for processing. Second, consider your studio's volume and the turnaround time your clients expect. A studio located in a mall, for instance, may require a high-speed, fast-turnaround printer to allow for same-day delivery.

PRINTERS AND SCANNERS

Before you begin shopping for printers and scanners for your studio, ask yourself the following questions:

- What will the equipment be used for?
- Will you use the scanner to upload images to the web for online proofing and ordering?
- Will you use your printer to generate professional prints and therefore require archival-quality ink?
- Would utilizing a variety of printers and scanners be more cost effective for your business?
- Should you purchase a less expensive printer for proofing and printing low-resolution images and reserve your more expensive, higher-quality printer for professional jobs?

On the other hand, a standard commercial or residential studio that focuses on quality, highly creative portraiture may not have the same needs.

As the general public becomes increasingly computer savvy, photographers need to ensure that their clients believe they are providing a valuable, professional service. A client may be willing to wait a week or more to pick up their final products if their perceived value is high enough!

Canon, Epson, Hewlett-Packard (HP), Kodak, and Sony all manufacture printers that are worth considering. Our studio currently uses an Epson inkjet printer and an HP laser printer. We send the bulk of our images to the lab for printing but use our inkjet printer to output watercolor-type prints and note cards. (Inkjet printers are favored by digital artists who create art prints, watercolors, and fine art media.) With its archival ink said to last 200 years, our inkjet printer is a good choice at a low cost. We use the HP laser printer to produce contact proofs, marketing materials, and more.

A color or black & white laser printer is a valuable tool for printing professional-looking office forms, Montage paperwork, contact sheets, and workbooks. Be sure to select a printer that offers archival inks.

PROOFING EQUIPMENT

Digital image capture makes the proofing process very cost effective. With digital files, you can proof in a variety of ways.

LCD Projector/Digital Portfolio. In this method, the client comes to the studio to view their proofs on an LCD projector. When the viewing session is complete, you can print out contact sheets and order forms and place them in a digital portfolio that your clients can take home. If you select this portfolio option, it is a good idea to use your studio name, rather than "Digital Portfolio" on the front of the book. This serves a dual purpose: it increases the visibility of your studio and eliminates any negative associations your client may have with the word "digital."

Selecting a projector is a personal decision, typically based on cost and the size and brightness of the room in which the proofs will be viewed. The higher the lumens, the brighter the image. For proofing purposes, 800 to 1200 lumens should be sufficient.

CD/DVD Proofing. Next, consider using a CD/DVD burner to cre-

During the proofing session, you can show images like this one via LCD projection and drum up some enthusiasm for the images. Photo by Jeff Hawkins.

ate your proofs. The cost is minimal, but the proofs have pizzazz! There are three different types of files a studio can offer their clients on a CD/DVD. The first is a large TIFF file, 8x10 inches at 300ppi, for reproduction purposes. These files can be used for headshots, advertisements, or other publicity purposes. The second option is a low-res JPEG file (4x6 inches at 72ppi). These smaller files are perfect for sharing images to be used on a website or sent via e-mail. Finally, the safest file type is a low-res executable file. This executable file will prevent the client from copying or saving the individual images. With this proofing method, consider using WnSoft's PicturestoExe (www.wnsoft.com). For added security, the software allows you to program a termination date into the proofing CD file, which will create an ordering urgency with your clients. You can also add a digital watermark to each of the files to prove copyright and authorship of the image.

Online Proofing and Ordering. Finally, online proofing can be an easy and cost-effective way to market your images. Typically, no extra equipment is required. Some of the most popular online ordering companies are: eventpix.com, morephotos.com, and marathonpress.com.

SCANNERS

Many film-based photographers use a flatbed scanner to begin the digital transition. Scanners are used to create a digital file from a processed print. The files can then be used for online proofing and ordering or album design.

For the very best results, consider buying a drum scanner. Because of their high cost, drum scanners are typically used in commercial labs. Some scanners come equipped with software that will remove dust, scratches, and other unwanted marks during scanning. Of course, Photoshop can be used to eliminate these flaws, but you may experience a loss of image quality, and adding this step to your workflow will increase the processing time.

When you install a new scanner, it should be calibrated the same as your monitor and printer (see pages 102–3).

In conclusion, because digital technology changes so rapidly, you will need to stay informed about and take advantage of the latest advances. As time goes on, it is necessary to reevaluate the effectiveness of your equipment.

The original image (top) was shot on Fuji film, then scanned. Vicki Popwell used Photoshop and Painter to transform the image into an elegant watercolor portrait (above).

4. Workflow

As discussed earlier, effectively and efficiently managing a digital workflow requires a set of skills that differ from those used in film photography. In order to gracefully make this transition and avoid a digital disaster, consider the following suggestions.

When proofing your images, consider adding a watermark and/or a logo to ensure copyright protection. Photo by Jeff Hawkins.

BALANCE

Beginning the digital integration requires planning, which in turn requires time *and* time management. Many photographers spend hours on the computer devouring the new technology and eventually neglect their businesses and their families. This is a dangerous path to travel. When someone is consumed by their business, they don't have much left to offer others. Discuss your new business goals with your personal and professional associates. Establish clear guidelines for what is considered educational time, work time, and personal time. No matter how successful you may feel or what your lifestyle is like, it is important not to work all day, every day.

DELEGATION

Whether your studio is big or small, the ability to delegate is key. Always ask yourself, "Can I make more money if I pay someone else to complete this task?" While doing everything yourself may seem like a cost-effective approach, consider the time involved in completing each task. If you spend countless hours every month trying to get your website up and running, it is probably not cost-effective to do the job yourself. On the other hand, if you

Below—Avoid a digital disaster and make sure you back up to avoid losing a perfect image. Photo by Vicki and Jed Taufer. **Facing page**—Delegating tasks to your employees allows you to focus your energy on your passion—taking great images. Photo by Jennifer George.

hire a top-notch website developer to redo your site, how many photo sessions would it take to recoup the money that you spent?

After you have delegated the tasks you feel confident in releasing, track your daily activities and determine how to best use your time.

AVOIDING DETOURS

To make the digital transition work for you, you must avoid detours. But this is easier said than done.

While photographers begin taking advantage of new technologies with the best intentions, many become overwhelmed and quit soon after they start. To stay focused during this critical period, you must map out a realistic course of action, research your options, develop a plan, and see it through.

In our studio, Jeff began the transition by studying basic photo manipulation techniques and the new technology available. By the time we purchased our first digital camera, we had a working knowledge of the new technology. After trying the camera out a few times, we felt confident in the capabilities of the camera system and began using it to capture our children's and family portraits. We quickly discovered the importance of having a file management system, backup batteries, backup CompactFlash cards, and a fast computer!

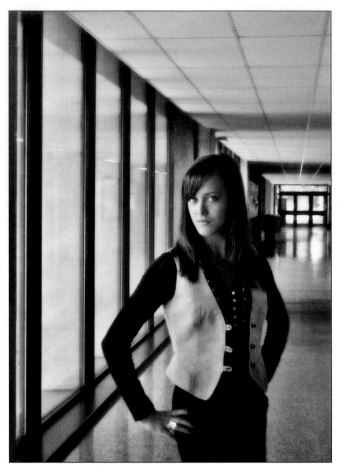

When shooting digitally, expose for the highlights to prevent blown-out highlight areas. Photo by Craig Minielly.

The key to making the digital transition work is commitment. As you gain experience, this process will become easier. In making the digital transition quickly, the sheer momentum (in part) kept us moving and gave us confidence that it could be done. We quickly realized that this transition could rejuvenate our excitement and enhance our creativity—and therefore set our studio apart. If we had to do it all over again, we would seek more help from others rather than trying to figure it all out for ourselves. Digital disasters can be averted with a little knowledge, and we have found that most photographers are happy to help when asked!

WORKFLOW TIPS

- Implement a system before heading out to photograph a single session. This will spare you some unnecessary headaches and anguish.
- You can prevent common digital disasters by backing up your work immediately! (Use a laptop to back up your images if you're shooting on location.) Never modify an image until you have saved the original file at least once; otherwise, you might alter an image so much that you'll forget what it looked like to begin with. Once the original image is altered, there is no going back, unless you shoot RAW.

5. Marketing

There was a time when digital technology meant low-budget, quick turn-around photography. Technology has since improved, and times have definitely changed. Today, if you want better cell phone service, top-notch sound from your audio equipment, or a faster Internet connection, you go digital! Likewise, if your client wants superior photographs, they hire a photographer who can offer a state-of-the-art digital experience.

In order to educate your market about the benefits of going digital, you have to prepare them for this style of imaging, sell them on the advantages it offers, and integrate new selling techniques.

EDUCATING YOUR CLIENT

Remember, while you may be excited about your new camera and the digital process, your excitement may not be shared by your clients. Your new

Update your mailers frequently with new images to keep your clients excited about your products and services. Photos by Vicki Popwell.

Your clients don't need to know every detail about how their images are created. Just let the results speak for themselves! Photo by Vicki and Jed Taufer.

style may actually scare them away—especially if you are not careful in selecting the words you use to discuss these changes.

Show, Don't Tell. As a photographer, you sell your art, not the process through which it is made. When your clients fall in love with your image style, it's the end result they are after. The point is, you do not need to discuss your digital equipment or the production process—after all, before you began this transition, did you feel compelled to educate them on your Hasselblad or what model of Canon you were using? Likely not. In fact, it may have even annoyed you when a client asked you what type of equipment you use. Now that you're shooting digitally, why should your approach be any different?

As a photographer, you sell your art, not the process through which it is made.

THE CONSULTATION

The consultation may be the most crucial stage in the sales process. Your client has seen your work, spoken with you on the phone, and now wants you to play a part in documenting their family history. At this stage, what you say may not be as important as how you say it. Consider these digital blunders:

> *Blunder: "We are a proofless studio!"*
> *Better: "Our state-of-the-art digital technology allows us to offer you more convenient proofing methods. All of our clients receive different proofing*

YOUR LOGO

Yourtown Photography
111 Main Street
Yourtown, FL 11111
(555)555-5554, (800)555-5555
www.yourwebsite.com
e-mail: photographer@yourstudio.com

PORTRAIT CLIENT INFORMATION

PERSONAL INFORMATION

Name:_____ Spouse:_____

Children's names: _____

Preferred location: ❏ Studio ❏ Home ❏ School ❏ Other_____

Do you have any pets? ❏ Yes ❏ No What Kind?_____

Address:_____

City:_____ State:_____ Zip:_____

Home phone:_____ Work phone:_____

Cell Phone:_____ Are you a Lifetime Portrait Program Club member? ❏ Yes ❏ No

E-mail address:_____

Web page address:_____

Physical aspects: ❏ Mobile ❏ Sits Okay ❏ Wheelchair ❏ Assisted Technology

PORTRAIT INTERESTS (Please check all that apply.)

❏ Family ❏ Children ❏ Pet ❏ Relationship ❏ Black & white ❏ Color ❏ Sepia

Size of prints typically desired: ❏ 5x7 ❏ 8x10 ❏ 11x14 ❏ 20x24 ❏ 30x40 ❏ Other_____

Do you usually custom frame your images? ❏ Yes ❏ No

Do you showcase your images in Fine Art Albums? ❏ Yes ❏ No

Location of images to be displayed? ❏ Living room ❏ Bedroom ❏ Office ❏ Hall ❏ Other_____

How often do you have portraits taken? ❏ 3–6 months ❏ Yearly ❏ 3–5 years ❏ 5 years or more ❏ Other_____

SPECIAL INSTRUCTIONS

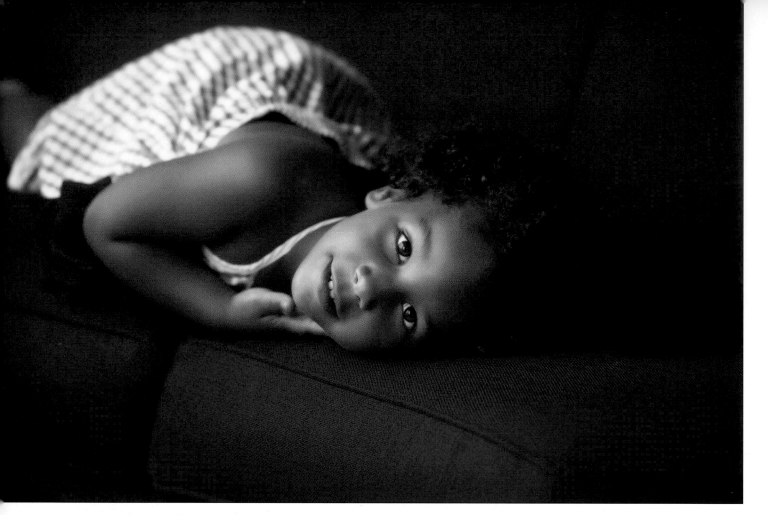

If your client is in a hurry to get their images, then make it appear as though you have made an exception in the workflow to accommodate their needs—and never get it done too quickly! Photo by Vicki and Jed Taufer.

options. You will receive online ordering for your family and friends, a proofing DVD, and a professionally bound contact sheet with each image numbered for reference. You don't have to worry about lugging and shipping heavy proof books ever again! Our families find this approach much easier and more convenient."

Implying that you are proofless is like telling your clients that they will receive less with you than with photographers who give away proofs! You *do* use proofs, you just don't use *paper* proofs. Now, doesn't the second option sound more appealing than the first? With the second option, it appears as though your clients are receiving more, thus increasing their perceived value of your product.

Blunder: *"We are completely digital!"*
Better: *"Our studio uses the latest state-of-the-art equipment. As an experienced portrait artist, your photographer will use whatever camera is most appropriate for what they are photographing. Don't worry, we have plenty of backup equipment! That is one of the main benefits to hiring an experienced studio."*

Again, doesn't the second option sound more appealing? Remember, many of our clients have been misinformed about digital imaging. They might think

that you are using the same digital camera as their Uncle Bob. If you have backup equipment, the above statement is 100 percent accurate. We can never guarantee that we'll be using a particular piece of equipment for a specific session. If something should happen to all the digital cameras in the world, then we would be forced to use our old film equipment before giving the client their money back. Even though you may shoot digitally 99 percent of the time, by selecting your wording carefully, you will overcome any client objections regarding camera equipment.

> **Blunder:** *"Oh, I can have that done in a minute. I'll just use my printer!"*
> **Better:** *"Let me see what our production schedule looks like and how quickly we can get that into processing. I will do my best to get your order processed as quickly as possible."*

Clients take comfort in knowing their images went through a magical chemical process. They are more often skeptical of the printing process than the

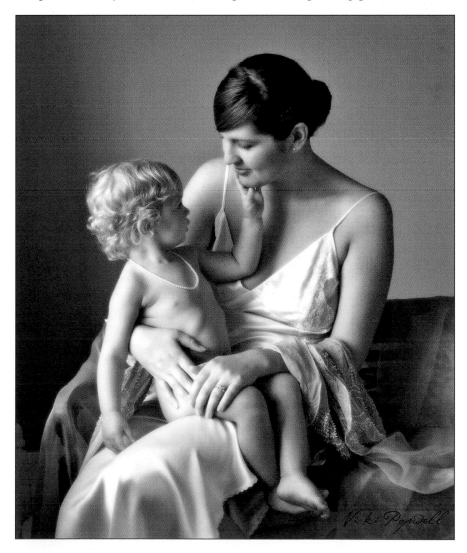

It's important to let your clients know that you believe every child and family group you photograph is different, and that each session is different. Photo by Vicki Popwell.

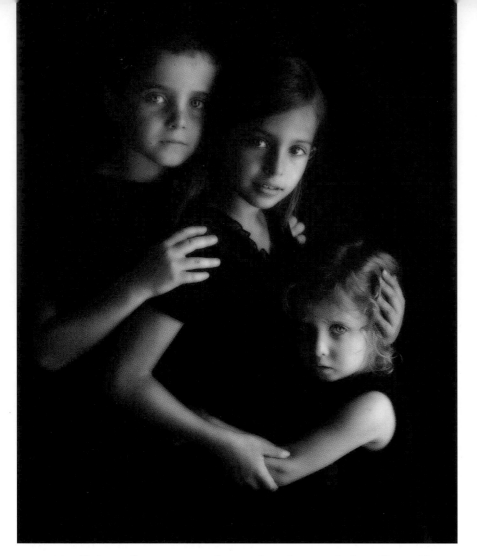

Be sure to discuss the archival inks used to make your prints with clients who are concerned about the longevity of digital images. Photo by Jennifer George.

camera itself. A too-fast turnaround seems less than magical to clients. If your client is in a hurry to get their images, then make it appear as though you have made an exception in the workflow to accommodate their needs—and never get it done too quickly! It may only take a few minutes to create a driver's license photo, but it takes more than a few minutes to create a work of art!

Also, never reveal too much information about the printers you use. As the quality of printers increases and prices drop, you will find that more and more clients have access to the same models. If your client comes right out and asks how the images are printed, then explain—but be sure to discuss the longevity of the prints and the archival inks. You would never want them to think they can create the same image you do! Your entire process—from image capture to presentation—should be a magical artistic process, a special talent that only you possess!

STUDIO ADVANTAGES

Once the client is focused on the quality of your portraiture, it is time to sell them on the advantages of working with your studio. Many photographers like to believe the images sell themselves, but unfortunately they don't. The client has to accept and believe in the perceived value of your product. Remember this: image + client's perceived value = money they will spend!

Many photographers like to believe images sell themselves, but unfortunately they don't.

As you run through the various benefits that your client can expect when they work with your studio, it is important to "close" the sale—to ask if the client can see how such a service will meet their needs. Try to get these questions in as often as possible throughout the conversation. You'll find some examples of how this works below.

Some of the benefits you may want to list in your studio's promotional materials are as follows:

"At John Doe Photography, we have no time limits, image limits, or set packages." This statement tells clients that we believe every child and family is different, and each session is special. We will photograph as many images as needed and will customize each session to meet that client's needs.

"With the purchase of a premier Day in a Life or Treasured Moments book (Montage Art or Futura Classic album), our clients receive their images archived on a DVD." We let clients know that this option is much safer than negatives, which may become scratched, bent, or misplaced. Many of our clients use their CD images as screen savers, to create thank-you notes, or e-mail them to family members and friends. We explain to clients that they can print out small images, but since we take the images through several additional processing steps, it is best to have their professional images printed at the studio.

Trial Close: Do you have access to a computer? Can you see the importance of both of us having a backup copy of such a treasured family heirloom?

"You do not have to worry about perceived imperfections on the day of the session!" We take each purchased image through an editing process, so our clients don't have to worry about imperfections in their portraits!

Trial Close: Can you get excited about being able to remove blemishes and other perceived imperfections?

"We come prepared to every session with plenty of backup equipment. We use only the latest state-of-the-art equipment to capture your images perfectly every time." Avoid mentioning specific cameras, technology, or equipment when discussing your work with your client. This way, you're not legally bound in the event of any unforeseen equipment malfunctions.

Trial Close: Do you take comfort in knowing that we will come prepared with more than one camera, just in case it is needed?

"We offer online ordering." All of our clients can order their images online. This means that they can share their images with friends and family, near or far, without needing to lug around heavy proof books. In fact, all they need to share is a website address and a privacy-protected password.

> We believe every child and family is different, and each session is special.

Allowing your clients' friends and families to view their images online can increase your profits and encourage word-of-mouth advertising. Photo by Craig Minielly.

Trial Close: Wouldn't you rather send your friends and family to our website than worry about shipping proof books all around the country and collecting orders? You don't have to be the middle man; let them come directly to us to place an order.

"You are not alone when designing your album." We care about the quality of our product. Your album is an heirloom, and we want to help you create a storybook, not a scrapbook. We will schedule an album design consultation session, during which we will walk you through the design process. It is our goal to have your album designed and placed into production within two weeks from your session! You will leave our studio with a printout of what your final product will look like.

Trial Close: Do you see the importance of using the photographs to capture a story like this book did?

WEBSITE ESSENTIALS

Don't embarrass yourself by handing out a business card that lists your website address if your site contains only your name, address, and phone number. This is a waste of your client's time, and they will repay you by taking their business elsewhere. Your website should entice and educate your clients and should allow the client's faraway friends and family to place orders online.

According to Dan Chuparkoff, an experienced software developer and website designer, there are five simple "pieces" to creating a successful Internet site:

Purpose: Determine the purpose of the site.
Identity: Select a name for the site.
Essence: Choose the content's depth and the frequency of changes.
Creation: Design the site with an experienced web design consultant.
Enlighten: Begin to advertise and to attract people to your site.

Purpose. What is the primary goal of a website, to advertise or to sell? Most people answer incorrectly—a website is not an advertising vehicle; instead, it should be used to aid in the closing of a sale.

As search engines evolve and people become more experienced at performing searches, browsers will more successfully find what they are looking for. Unfortunately, in the web's current incarnation, you cannot rely on attracting customers in this way. Instead, use your traditional advertising strategy to draw clients to your site.

Ideally, your website should allow visitors to painlessly purchase your images or register for your services. At the very least, make sure your site provides up-to-date samples of your work and a section that allows clients to discover the products available for purchase.

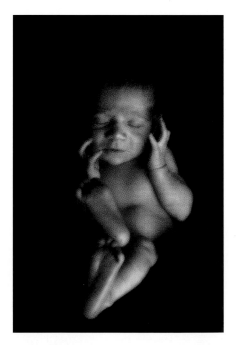

Proud grandparents and faraway relatives should be able to painlessly order images on your website. Photo by Jennifer George.

Your website should feature up-to-date portrait examples that will compel viewers to book a portrait session. Photo by Joann Muñoz.

The next step in crafting a website is selecting a name for the site.

Identity. The next step in crafting a website is selecting a name for the site, also known as your "domain name." Your studio name is an obvious first choice. To find out if that domain name is available, you will need to go to an accredited registration service like www.internic.net or www.register.com. If your business name is a registered trade name and is being used by someone as a domain name, you may have legal rights to that domain name. You may dispute such conflicts similarly to disputing other trade name violations.

Try surfing over to a registration site to see if your chosen domain name is available. If your first choice is unavailable, remember the following tips when choosing a different name:

- You may only use letters, numbers, and the hyphen character (-).
- Avoid the use of homophones ("by" and "buy"; "for" and "four"). They add confusion when passing the site's name along by word of mouth.
- Try to anticipate your company's future growth when choosing a site name. The name www.jeffhawkinsphotography.com is good for a photographer's site, but it would be slightly less suitable if used to promote the consulting services provided by Jeff Hawkins.
- Somewhere near 99 percent of the words in the English language are already taken, so don't expect www.photos.com to be available. Be prepared to spend some time looking for a name that isn't already held.

Essence. Determining the depth of your Internet presence can be more important than time spent on design and style. It is also the most difficult step in constructing your site.

As noted earlier, your prospective client will likely have non-Internet contact (e.g., an advertisement or a referral) before surfing over to your site. With every interaction with your studio (be it personal, on the web, or in print), you run the risk that your client will get bored, distracted, or will somehow become motivated to go elsewhere. It is important to ensure that your site offers a clear, specific benefit to the customer.

Immediate gratification is very important to web users. They don't want to wait to meet with you to get the answers to their questions, so give them what they want: If you have ever received a request for your portfolio, your biography, or references, then put these things on your site. Provide viewers the opportunity to purchase or register for your services through the website. This way, you remove the opportunity for them to change their mind while they wait for your e-mail response or scheduled appointment.

Your website should showcase images that represent the full range of styles you shoot, since not every image will appeal to every viewer. Photo by Jennifer George.

As previously suggested, creating an online ordering system is indisputably the best way to profitably capitalize on the flow of traffic onto your site. For a set fee, your clients, their families, and their friends can view and purchase your products quickly and easily—without the need to pass along or ship heavy proof books. We recommend that the number of the images, the selection of the portraits, and length of online visibility be selected at the discretion of the photographer. For more information on online ordering, contact eventpix.com. The cost is minimal and the response can be incredible. Other sites, like www.marathonpress.com and www.morephotos.com, may be equally useful.

Creation. In most cases, you will want the help of a web design consultant to create an effective Internet presence that results in a positive user ex-

Limit the text on your website to ensure that the focus remains where you want it—on great images like this one. Photo by Frank Donnino.

perience and, more importantly, increased sales. If you want to take a stab at it on your own, try Microsoft's FrontPage. In order to add some of the really productive components like online ordering, online registration, or an automated response system, you will probably benefit from at least consulting an experienced Internet professional. Enlisting the help of a designer will also save you from the pressure of trying to register your own domain name and from trying to find a site-hosting service.

Choosing a web designer is a difficult task and may require several attempts. Depending on the depth of your site's content and the frequency of your changes, the fee for this service can range from just a few hundred dollars to several thousand. If you have not received a referral from a reliable source, search for "web designer" in the Yellow Pages or use a search engine. Remember, your web designer need not live in the same city (or even country) as you, since most contact with your designer will be conducted via e-mail and through the Internet.

If you do location photography, be sure to show images like these on your website. Right photo by Craig Minielly. Bottom photo by Frank Donnino.

home | bio | portfolio | request | ordering | comments | products | news flash | top 10 | portrait program

jeff Hawkins photography

Real Emotions,

Real Moments,

Real Lives,

Your Story!

When only the finest will do...

327 Wilma Street, Longwood, FL 32750 Tel: 407.834.8023 Toll Free: 800.822.0816
jeff@jeffhawkins.com kathleen@jeffhawkins.com www.jeffhawkins.com

According to web designer Dan Chuparkoff, there are four things to consider before hiring a website designer:

- Look at their past work.
- Have them create a low-cost prototype before committing to the entire project.
- Discuss availability in the future to update information as it changes.
- Get quotes from several different designers (they will vary dramatically).

When designing (or helping to design) your website, keep in mind that a well-planned, easy-to-navigate site is crucial to creating a pleasant user experience. Keep it simple, using typical web standards. Only use underlined text, for instance, if that text is a link to another page. Internet users have been conditioned to expect certain things to happen as they view a site. For instance, people know that when they see a tiny picture (commonly called a thumbnail) they can click on it to see a larger view. Keep these conventions in mind, but don't compromise your style and expression. Just as you would "dress for success" when meeting with a prospective client, your website should communicate exactly what your personal appearance would convey in a face-to-face meeting.

Furthermore, your site should be dynamic and uncluttered; make sure that the spotlight is on your images, not on excessive text. After all, families are visiting your website to see your gallery and view your images. Ensure that this is where you focus your attention, and make navigating through the images as easy as possible for viewers.

You will also want to be sure that you update your site frequently to ensure that your most recent work is displayed. The ability to keep your site fresh is priceless! (Obtain model releases for every image showcased on your site! Model releases are especially important in children's photography. There

Make sure that the spotlight is on your images, not on excessive text.

are many sample model release forms and additional information on this topic at www.ppa.com. It is important to review these rules when placing images online, using them in a gallery, or on the web.)

It is very important to keep your loading time for your images as short as possible; the last thing you want to do is lose customers at this point. Keep in mind that not everyone viewing your site has a computer as fast as yours. To make your site as viewer-friendly as possible, duplicate your image files, set a resolution of 72ppi, and save them in the JPEG format. Also, be sure to provide thumbnails to any large images on your site. This will considerably shorten the time it takes for your pages to load.

When you are finally finished with your site's creation, test it on the slowest PC you can find. Try to determine if your prospective client would have been patient enough to wait for the whole page to load.

Enlighten. Finally, you must spread the word that you have a website and let people know how to get there. After all, just because you have a website does not mean that everyone will surf onto it. Networking and word of mouth are still the most effective form of advertising. Make sure you include your new web address in all of your promotional materials—from mailers, to business cards, to your letterhead. Make sure you send e-mails out to every-

It is very important to keep the loading time for your images as short as possible; the last thing you want to do is lose customers at this point. Photo by Jeff Hawkins.

HELPFUL HINT

Pretend for a minute that somewhere there is a small children's photography company. The owners decide to create a website, because they realize that not having one will have a negative impact on their business. The proprietors create a small web page with their company name on it, complete with the studio address and phone number. The page might even contain a picture of the crew and all of their equipment, perhaps the studio location, and a few props. They need to select a name for the website. It just so happens that the domain name www.getchildrensphotos.com is available, so they register this name as their new website address.

Now, imagine that a new mom living in a metropolitan area is in need of a portrait photographer. Unsure where to begin her search, she turns to the web. As an experienced web surfer, she knows to first head to a popular search engine and type in a few words to get her started: she selects "children's portraiture" or "children's photographer" (try this yourself!). Fortunately for the above-mentioned studio, these words appear on the hastily designed website. Unfortunately, according to Yahoo! those same words also appear on about 38,300 other web pages. The website www.getchildrensphotos.com is somewhere on that list of 38,300.

With a lot of luck and some skillful use of key words explicitly describing the site's content (called metatags), the website might even appear somewhere in the first 2,000 entries. If the mom had the time to search through about 100 of these sites, she would likely find that many of these photographers were located far from her home. The moral of the story is, just because you put a website on the Internet does not mean that anyone will ever find it!

With relatively few hits on their website, the studio quickly learns that they must develop a new strategy. In an attempt to increase their visibility on the web, they have their web address printed on their business cards, letterhead, and advertisements.

one in your address book—from former clients to vendors—informing them about your new site. Also consider adding a signature line like "Visit our website at www.johndoestudio.com" at the bottom of every e-mail you send.

When choosing where to advertise, watch your advertising dollars carefully. Take advantage of free links! In some cases, you can submit your website (and perhaps your work), and the partnering website will post your

Make sure that your website's image load time is short so interested viewers don't get bored and leave your site before they see your work! Photos by Vicki and Jed Taufer.

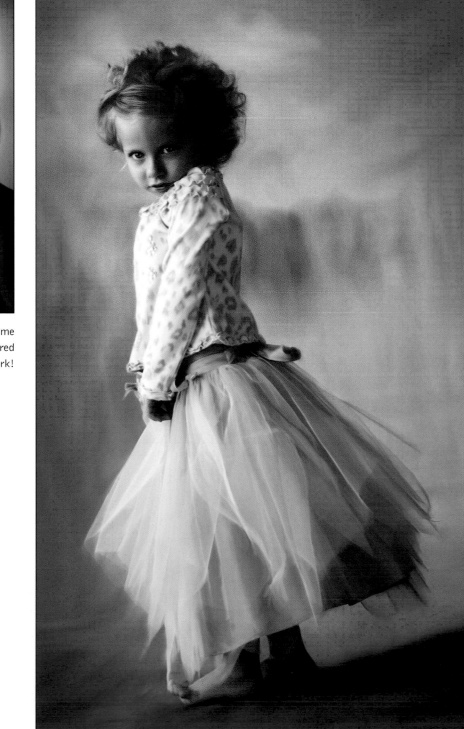

information at no charge. However, some sites negotiate a link exchange. This is where they attach a link to your site on their web page and vice versa. We don't personally recommend participating in a link exchange program, since it sends the viewer away from your site rather than keeping them there.

MARKETING TIPS THAT MAKE YOU MONEY!

1. To capitalize on impulse purchases and expedite their workflow, many studios utilize a post-session sales consultation, which is held immediately after the session or within seventy-two hours of the session's com-

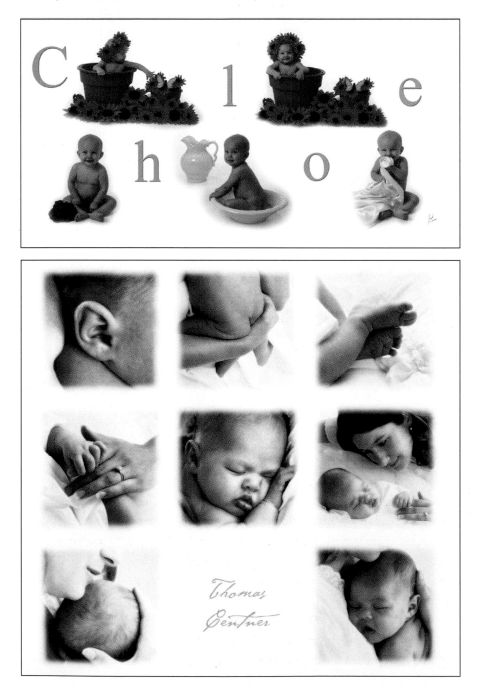

Top—Frank Donnino's What's in the Name? children's portrait panel keeps clients coming back for more. **Bottom**—Vicki Popwell's panel images include close-up shots of the baby's most endearing features, plus tender images with Mom and Dad.

Vicki Popwell uses elegantly designed note cards to promote the many different image types she creates and the variety of sessions she offers.

pletion. During this time, clients can view their digital images on a computer screen or on a large LCD projector screen. When you use MontagePro or TDA software, clients can see the album design unfold in front of their eyes. Photographer Joann Muñoz says, "Eliminating paper proofs is a great benefit of digital marketing! Seeing the image right away creates excitement, and clients will order a lot more and much faster!"

2. Jeff Hawkins states, "Digital technology allows the opportunity to provide stock images to vendors and receive free advertising!" After each session, we take a close look at each image and determine if there is a place where it can be marketed. (It is important to think outside the

box: We have provided images to small dress shops and new housing subdivisions, for instance, in exchange for advertising benefits!) It is critical that you implement a system for identifying any stock images and organize your digital files in categories, so they can be easily tracked. Be sure you obtain a model release for any image you wish to use for stock.

3. Photographer Frank Donnino has great success promoting his unique What's in the Name? children's portrait panel, which is created in Photoshop and designed at the discretion of the studio. This type of product offers clients something more creative than a traditional portrait, which encourages them to visit the studio more frequently.

4. Jeff Hawkins promotes panel frames with a series of images. He creates a 8x20-inch frame design in Photoshop and then adds the child's name or a verse to the design. As a bonus he offers the client one panel framed for $325 and offers the second as a bonus for only $150. It increases the clients' perceived value of the product and makes them feel positive about their experience and purchase.

5. Many photographers now offer a unique style of photography that documents the baby's first year of life. This photo montage captures the milestones in the subject's life over several sessions or throughout a single day. The images are typically taken in the child's natural surroundings—at home with their toys or at a familiar park or their school, for instance. The exciting new digital flush-mount series albums or the Montage Art books are perfect for this style of baby photojournalism.

Above—Jeff Hawkins' folios and image series are always popular with his clients. **Facing page**—Here are select pages from Sherri Ebert's album, which earned a 100 percent score at the 2002 Florida State Photography Convention, are shown here. Sherri has also received the Becker Award for Creative Photography (2002); Fuji Masterpiece Award; First-Time Album, and Florida's Top Ten Award. In addition, Sherri received a First Place Award for Informal Non-Event Album and was accepted into the PPA Loan Collection in 2003.

The Miracle of a

Baby

Joshua Gabriel
Born
July 23, 2002
to
April and Stan Fisher

...what a fabulous experience it was to watch you grow!

W

Waiting, preparing

A

And then finally...
on a warm evening in July...

...it was time.

A

A long, hard night turned into a long, hard, emotional day.

A

And then, a gift from God – our CHILD was born!

F

Feelings indescribable, an incomprehensible, unbelievable MIRACLE!

T

Ten tiny fingers,

...and ten tiny TOES.

H

He was perfect.
He was our SON!

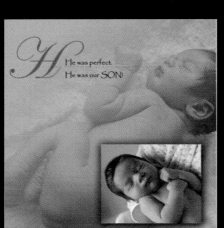

And we named him *Joshua*

6. Planning the Shoot

Once the client is ready to schedule their session, you should outline the steps they must take to ensure the best-possible portraits.

CLOTHING

Most clients require some guidance in selecting clothing that will work well for their portraits. Be sure to educate your clients on what works—and what doesn't—before the day of their session.

While moms and dads might be reluctant to appear in any images taken during a child's portrait session, make sure that they follow the clothing

When photographing groups, clothing choices are even more critical. Ensure that all of your clients are well educated about the type of clothing that works well for portraits. Photos by Frank Donnino.

Well-coordinated clothing suited to the location helps to make this a great family portrait. Photo by Frank Donnino.

guidelines, too. After all, images that hint at the camera-shy parent's presence can beautifully illustrate the parent–child bond. An image in which the child is clinging to a parent's leg or a toddler is loosely grasping Mom or Dad's hand speaks volumes about their relationship.

Here are a few clothing suggestions to share with your clients:

- Choose outfits that fit the personality.
- Avoid heavy patterns or stripes. A phenomenon called pixel havoc can occur when a client is wearing a patterned suit or shirt such as tweed or herringbone. Anything with a crisscross pattern or tightly woven pattern can cause a moiré pattern in your digital image.
- For group portraits, be sure that the clothing of all of the subjects is color coordinated.
- Solid, neutral colors look best. When shooting digitally, white clothing can pose a problem in that the highlights tend to appear blown out.
- Avoid short skirts or shorts. This makes posing more difficult. Long, flowing dresses, jeans, or khakis make better selections.

PROPS FOR CHILDREN'S THEME IMAGES

Hats, sunglasses, and similar items can add pizazz to children's portraits. Similarly, clothing that encourages role-playing—a chef's hat, firefighter's jacket,

A prop can personalize portraits and make them unique—even if it's just a little mud! Photo by Vicki and Jed Taufer.

or any such gear—can inspire a great image. With babies and toddlers, large props like a bassinet, oversized flowerpot, basket, or birdbath can serve as seating devices and add a lot of dimension to the image. In our studio, these serve as base props, then we add others—a baby doll, carriage, teddy bear, or fire truck—from there. Another great idea for implementing theme portraiture is to create limited-edition portraits. For instance, Vicki and Jed Taufer offer Furry Friends, Little Ballerina, and Children's Formal portraits for a set amount of time.

FAMILY PORTRAIT PROPS

Props aren't just for kids. In fact, they can add a lot of interest to your family portraits as well. This can make your photograph unique. Among those props to consider are a picnic basket, a musical instrument, or even pets. We can also work with larger objects such as boats, sports cars, planes, or motorcycles. A photo of a parent and child with a few simple props—like a bedtime storybook and a favorite stuffed animal—can be very charming.

PERSONALIZED IMAGES

The best images have a lot of impact. We tell our clients to relax and enjoy themselves, and we create images that speak volumes about who they are—through props, clothing, expressions, and even the image style they choose. It is important to remain open to interesting photo possibilities; fortunately, there is inspiration around every corner—whether it's a postcard or an ad in a magazine. (We frequently re-create well-known artwork with our clients as the subjects!)

The more you personalize your portraits, the greater their impact. Adding the family dog to this shot made the portrait even more special. Photo by Frank Donnino.

7. Capture

It is much easier for a studio to operate photographing 100 percent digitally than to capture 50 percent of its images with film and the remaining 50 percent with a digital camera. In order to competently capture digital portraits, however, everyone at your studio will need to implement some changes.

ORGANIZATIONAL MODIFICATIONS

To run a successful digital studio, you will need to retrain your assistants and production staff. Once you have taught your associates the new computer technology, the importance of the storage device requirements, and the benefits to your business and workflow that digital imaging will provide, you will all feel more confident in your new duties.

If you are not currently using an assistant in your portrait sessions, you should strongly consider doing so. Some of the most respected children's and family photographers in the industry use an assistant to engage the kids and/or assist in capturing priceless images.

Educate your assistant on how to transfer and save files from a CompactFlash card or other storage device. Then take a few fun photographs and work through the process until it is instinctive and natural. Consider giving your assistant your backup camera and allowing

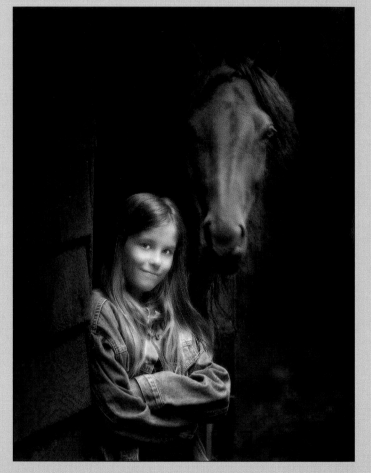

Digital imaging has changed children's and family portrait photography forever. Photo by Craig Minielly.

them to photograph the child at a different angle. This is especially useful at special events or for Day in the Life or Treasured Moments sessions. (An ability to be in more than one place at a time is a real selling point for your clients, too!) As you make your transition to digital, be certain to acknowledge your assistant's fears and help them overcome their concerns with training and support.

With digital, you'll capture more images and a wider array of expressions and unforgettable moments. You can also easily diversify your portfolio with special artistic effects like sepia toning. Photo by Jennifer George.

STYLE

The next step is to analyze your studio's style and photographic process. How might this vary from film to digital? Although it might not be obvious, your shooting style will change because of the number of images you can capture and the quality of the photographs. The ability to preview each image instantly means that you can take risks, and if you don't like the exposure, pose, or composition, you can delete the file and try again. With digital capture, exposure and color latitude will be much tighter. Being able to view the image instantly allows you to experiment with lighting, time exposures, silhouettes, etc., and to ensure that the image is perfect before moving on to the next frame.

The features found on a digital camera vary from one model to the next. When converting to digital coverage, consider the following:

• Once you have selected your digital camera equipment, begin using it to supplement your existing equipment. Try different settings, such as the black & white mode, and use different aperture and shutter speed combinations. Remember, capturing several images costs as much as shooting just one!
• Determine the impact that shooting at various ISO settings will have on the amount of "noise" (the visible results of an electronic information error from a digital camera) in your images. Visible noise in an image is

The best images are created when clients just relax and act like themselves. Photo by Vicki and Jed Taufer.

often influenced by a higher ISO rate, the temperature (high=worse, low=better), and the length of exposure (longer exposure=more noise).

- Determine whether you prefer to conduct your sessions in RAW mode or JPEG Fine mode. Shooting in RAW mode requires the use of a software program that can decipher the RAW code. From that point, you can edit and save the images and convert the files to another mode. If your camera gives you the ability to shoot in JPEG Fine mode, run some test images in this mode as well. Shooting in JPEG Fine mode creates smaller files, so you can save more images on a storage device and it doesn't take as long to write the file to memory. This mode allows you to work faster, which is often helpful when working with children. The drawback is that the JPEG compression can compromise the image data. This can be a hindrance if your studio sells a lot of 30x40-inch portraits.
- Make sure you have extra camera batteries. In the beginning, you will find yourself looking at the LCD screen a lot. This drains the power.
- As a rule of thumb, expose as though you were shooting transparency film. With digital, it is better to slightly underexpose than to overexpose.

8. Postproduction

Bring a laptop with you when shooting on location, and back up your images after each session. Photo by Jeff Hawkins.

You have conducted your session and captured a lot of great images. Now what do you do? In this chapter, we will explore three important procedures: saving the images, creating special effects, and beginning the proofing process.

Store your finished images in a folder labeled with your client's name to ensure easy retrieval should your client want to reorder prints. Photo by Jennifer George.

OVERVIEW

Once your session is complete, you will need to transfer your image files from the memory card to your computer and reformat the card (see the owner's manual for your camera) so it is ready to be used again. Make sure the images are fully copied to the portrait folder on your hard drive before deleting them from the storage device. (*Note:* When transferring image files, always use the copy command and not the move command; this way, if there is a power glitch during the move, you won't lose your files. If you are on loca-

Programs like iView MediaPro (top) and Adobe Bridge (bottom) make viewing and organizing all of the images from your session a simple, straightforward task.

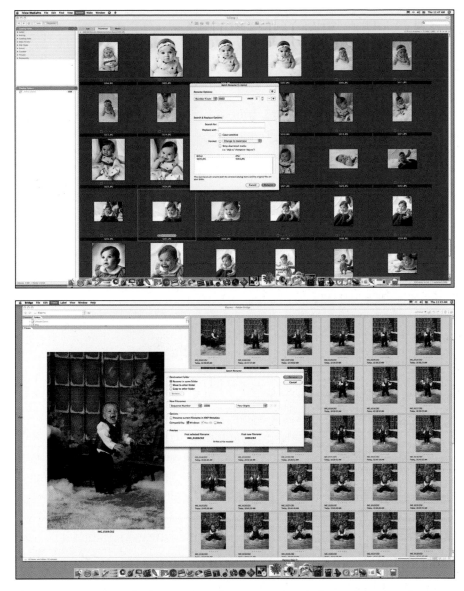

IMAGE COMPRESSION

When saving files in the JPEG format, set the Quality field to 5 under Image Options for website images and 12 for images you plan to print. The larger the number, the less compressed the file will be.

tion, you can copy the images to a laptop or simply leave them on the storage device until you return to the studio.) Back up the original files using a CD or DVD burner. This is done for reassurance only—the backup files are generally not used. (Skip this step if you're using a backup server and server tape system.)

Next, open the portrait folder and create a subfolder with the client's name (e.g., Johnson/backup). Transfer the images into this subfolder, again using the copy command. Then open the files in a file viewing program such as Adobe Bridge or iView MediaPro (www.iview-multimedia.com). After the files have loaded, run a batch renumber process, so the images are arranged chronologically.

With this accomplished, notify the person (or department) responsible for creative enhancements that the images have been burned to CD or DVD. Some basic retouching should be done at this point. Now is also a good time

to select five or six images that appeal to you and have your staff add some artistic enhancements. Once the proofs are ready, a proof portfolio will be made (if applicable) and a CD/DVD will be burned. Next, the client is called to view their proofs. When your clients see the effects that can be added to their images, you'll spark their interest in ordering more images. Though the original client folder on the hard drive can be deleted if the file takes up too much space, we prefer to leave it on the hard drive until the proofs are completed, the images are modified, and the order has been placed and processed.

Once the client views their images and places an order, we activate their thirty-day online viewing period, free of charge.

TIME-SAVING TIPS
◉ Pressing the Alt/Opt key as you double click on the layer will allow you to rename the layer.
◉ Pressing the Alt/Opt key as you click on the layer mask in a regular layer allows you to see the mask instead of the image.

POPULAR ENHANCEMENTS

As mentioned above, adding artistic effects is an important part of the production process. In the remainder of this chapter, we will look at some of the most popular artistic enhancements. These include:

1. Convert images to black & white.
2. Convert images to sepia.
3. Create a vignette using the spotlight effect.
4. Convert images to watercolor.
5. Make the image part black & white, part color.
6. Use Nik Software's Monday Morning filter to tone the image.
7. Use Nik Software's Duplex filter to create a duotone effect.
8. Add a border with Auto FX's Photo/Graphic Edges (www.autofx.com).
9. Add a digital mat to an image using John Hartman's QUICKMats.

Below, we'll look at the various processes you can use to create stand-out images and build a bigger profit line.

LAYERS

Consider working in layers to increase control and make correcting your mistakes easier. Think of layers as several transparencies stacked one atop another to create a composite image. Though there are many image layers, you can see how the various layers work together. In Photoshop, you can create a layer, add an effect to it, composite the layer with the original image, and determine whether or not the effect works. If you are not satisfied with the results, you can simply discard the layer to return to the original image—either to start the corrections over or to accept the image as is. If you want to apply your changes to the original image, you can simply flatten the layer.

Creating a Background Layer Copy. Creating a copy of the background layer allows you to manipulate an image without committing to the results. You can try out a variety of effects and, if you're not satisfied with the results, you can simply drag your background copy layer into the trash.

Duplicating the background layer is easy in Photoshop.

1. In Photoshop, open an image from the work folder.
2. Go to the Layers palette at the bottom right of the screen.
3. Click on the background layer to activate it.
4. Drag the background layer down to the Create New Layer icon and release to create a background layer copy.
5. With the background copy layer selected, manipulate the image.
6. Once you are satisfied with the effect you've applied, go to Layer> Flatten Image. This will merge the layers.
7. Save and close the image.

The following are step-by-step procedures for creating the effects most commonly used with our children's and family portraits. You may want to start with these procedures, then develop additional ones on your own.

SPECIAL EFFECTS

Convert Images to Black & White. Photoshop makes it easy for you to convert your color images to black & white.

1. In Photoshop, open an image from the work folder.
2. Go to Image>Adjustments>Channel Mixer.
3. Click on the box labeled Monochrome. You can then accept the image as is or make further adjustments.
4. If you wish to adjust your image, manipulate the sliders. To maintain the original brightness and contrast, the values of the sliders must total 100% (for example, if the Red slider is set to +70% and the Blue slider is at +0%, then the Green slider should be set to +30%).
5. When you are happy with the result, click OK.
6. Save and close the image.

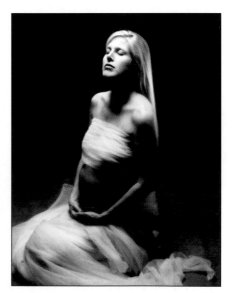

Left—The Channel Mixer dialog box settings used to produce the black & white conversion. **Center and right**—The original color image and its black & white version. Photos by Jeff Hawkins.

Convert Images to Sepia. A sepia tone can be easily added to an image to create an aged, vintage look in the portrait. This is a popular option in family portraiture. To create this look in Photoshop, take the following steps:

DON'T PANIC!
Don't panic if you mess up—just hold down Ctrl/Alt and hit Z to undo the most recent step.

1. In Photoshop, open an image from the work folder.
2. Open the Actions palette (Window>Actions).
3. Next, go to default actions and click on Sepia Toning (layer), then click the Play button. (If the Sepia Toning action does not appear in your Default folder, click on the black arrow at the top-right corner of the Actions palette, go to Load Actions>Photoshop Actions>Image Effects, then click Load.)
4. To adjust the intensity of the sepia tone, go to the Layers palette. Notice the three layers available: the background layer, layer 1, and a Hue/Saturation layer. Double click on the Histogram icon in the Hue/Saturation layer. Adjust the saturation to your liking.
5. Flatten, save, and close the image. (*Note:* You can also make the adjustments using the Variations feature [Image>Adjustments>Variations]. If using a color image, however, be sure to desaturate it first.)

Top right—Select the sepia toning action in the Actions palette, then click the triangular Play button at the bottom of the palette to create the sepia effect. **Bottom left and right**—The sepia image keeps the focus on the subject and has a timeless appeal. Photos by Jeff Hawkins.

Above—The Soft Omni dialog box. **Right**—The color original and the final image with the Soft Omni effect. Photos by Jeff Hawkins.

Create a Vignette with the Soft Omni Effect. Create a vignette with the Soft Omni effect to highlight the subject or main focus in an image by darkening the area surrounding your subject. (*Note:* This effect also works nicely on black & white images.)

1. In Photoshop, open an image from the work folder and create a background layer copy.
2. Go to Filter>Render>Lighting Effects.
3. Select Soft Omni from the Style pull-down menu.
4. At the left of the dialog box, you will see your image, surrounded with a circle. You can click on and move a "handle" in or out to adjust the effect to your liking.
5. Using the Ambience slider, you can further manipulate the effect to your liking. This will increase or decrease the effect of the spotlight.
6. Click OK.
7. Flatten, save, and close the image.

Convert Images to Watercolor using Corel Painter. By creating a hand-painted, watercolor effect, you can increase your client's perceived value of an image and increase your sales. Here's how it's done:

1. In Painter, open an image from the work folder.
2. From the menu bar, go to File>Clone. Rename the cloned image, and save it in the work folder.
3. Next, go to Window>Screen Toggle Mode>Zoom to Fit.
4. Click Select All and press Delete the key. You will now have a white canvas.
5. From the Brush Selector bar, select Cloners>Soft Cloner. Select a large brush with medium opacity, then use it to paint over the white canvas to "bring back" the main image.

6. Save the image.

7. Go to Blenders>Just Add Water. Increase the brush size to your liking and paint in the background areas of the image. For areas with fine detail, use a dabbing motion. Also, be sure to follow the lines in your image for a natural look.

8. With these steps complete, save the file and print your image on fine art watercolor paper. (*Note:* Mastering this program requires time and patience. Once you have a working knowledge of the program, you will be able to produce truly unique, hand-painted works of art. The use of a graphics tablet and stylus is essential when painting.)

Corel Painter allows you to create beautiful, painterly images (left). The original image is shown below. Photos by Vicki Popwell.

You can convert an original color image (above) to black & white and selectively add color for a hand-colored look (right). Photos by Jeff Hawkins.

Make Images Part Black & White, Part Color. To create the old hand-tinted, part black & white/part color effect, use the steps outlined below. You'll find that certain black & white images really benefit from the selective application of color.

1. In Photoshop, open an image from the work folder and create a back-ground copy layer (see pages 82–83).
2. With the new layer activated, follow steps 2–6 of "Convert Images to Black & White" (see page 83).
3. Select the magnifying glass and zoom in to a 200% enlarged image view.
4. Select the Eraser tool and adjust the brush size as needed to allow for precise work in the desired area.
5. Using the Eraser tool, remove the areas of the black & white image that you want to appear in color. This will allow the color image (in the back-ground layer) to show through in the selected areas.
6. Control the intensity of the effect by adjusting the opacity of the Eraser tool. Selecting an opacity setting of less than 100% will leave some of the black & white image visible, so the color image will appear less intense.
7. Go to Layer>Flatten Image to merge the color and black & white layers.
8. Save and close the image. (*Note:* You should always work at a 200% [or more] enlarged view when retouching. This will allow you to see more detail and ensure that your retouching is accurate!)

SPECIAL EFFECTS PLUG-INS

There are several plug-ins available for Photoshop users that will create some very desirable effects. You'll find images created with a few of those filters on the following pages.

Nik Software's Monday Morning Filter. This filter allows you to con-trol detail and light while softening an image and adding various tones (through the Monday Morning sepia, Monday Morning violet, or Monday Morning blue filters).

Nik Software's Monday Morning filter allows you to control detail and light while softening your image. **Top left**—The original image. **Top right**—The Monday Morning filter dialog box. **Bottom**—The final image. Photos by Jeff Hawkins.

1. In Photoshop, open an image from the work folder and create a background layer copy.
2. With the background copy layer selected, go to Filter>Nik Color Efex Pro!>Monday Morning (or another Monday Morning filter, such as Monday Morning [violet]).
3. Locate the four sliders on the window (Grain, Brightness, Smear, Color).
4. Begin with the Grain slider and adjust the effect to your liking. (To zoom in or out for a better view, click on the + or – symbols at the top-right corner of the screen.)
5. Next, adjust the Brightness slider. (*Caution!* If an image displays a lot of brightness or hot spots, the detail may appear blown out when the filter is applied.)

6. To add softness to the image, adjust the Smear slider to your liking.
7. Use the Color slider to add or subtract the color to your liking.
8. Once the image appeals to you, hit OK. The filter will then be applied.
9. Go to Layer>Flatten Image to merge the layers.
10. Save and close the image.

Nik Software's Duplex Filter. This filter can be used to produce a duotone effect in your images.

1. In Photoshop, open an image from the work folder and create a background layer copy.
2. With the background layer copy selected, go to Filter>nik Color Efex Pro!>Duplex.

Nik Software's Duplex filter can be used to produce a duotone effect in your images. **Top left**—The original image. **Above**—The Duplex filter dialog box. **Right**—The final duotone image. Photos by Jeff Hawkins.

3. Click on the color swatch located in the lower-left area of the dialog box. This will bring up the Color Picker. Select a shade that appeals to you using the Color Picker or simply enter numerical values into the color fields. (*Caution!* If an image displays a lot of brightness or hot spots, the detail may appear blown out after this filter is applied.)
4. Once the image is to your liking, hit OK. The filter will then be applied.
5. Go to Layer>Flatten Image to merge the layers.
6. Save and close the image.

Auto FX's Photo/Graphic Edges Software. This software can be used to create a number of interesting artistic edges for your photographic images.

1. In Photoshop, open an image from the work folder and create a background layer copy.
2. Go to Filter>Auto FX>Photo/Graphic Edges.
3. Left-click in the Select Edge window in the lower left of the screen. Be sure the Show Preview box is selected.

Auto FX's Photo/Graphic Edges software can be used to create artistic edges for your images. **Top**—Original image. **Above**—Photo/Graphic Edges dialog box showing the available selections. **Left**—The final image with the filter applied. Photos by Jeff Hawkins.

4. Click on the file name to see a sample of what the edge looks like.
5. Once you have found the edge you want, select OK.
6. You can then elect to apply specific edging (e.g., drop shadow, beveled, carve, grain, burn, glow, etc.).
7. Hit Apply.
8. Go to Layer>Flatten Image to merge the layers.
9. Save and close the image.

John Hartman's QUICKMats Software. This software can be used to add a digital mat or liner to your images.

1. In Photoshop, open an image from the work folder and create a background layer copy.
2. With the new background layer copy selected, open the image and the mat on your desktop, so you can view both at the same time.
3. Click the Move tool, drag the image over the mat, then drop it into the mat opening.
4. Go to the Layers palette and drag the image layer so it is at the bottom of the layers. The image will now be positioned below the liner layer.
5. Click the Move tool and, with the image layer still selected, drag the image around until it is centered behind the liner layer.
6. Adjust to your liking. The software can also be used to add color and texture to the mat and the liner.
7. Go to Layer>Flatten Image to merge the layers.
8. Save and close the image.

Using the steps shown below, you can easily use John Hartman's QUICKMats program to produce a digitally matted image your clients will love. Photos by Jeff Hawkins.

TRACKING MODIFICATIONS

We use an Image Modification form to track our workflow. It is important to identify what modifications you use. After all, a client could come back many months from now with a request for a duplicate image. It is impossible to rely on memory alone!

This form is placed on the photographer's or creative artist's desk at the time the client's work folder is prepared. Typically, modifications are done within a twenty-four- to forty-eight-hour time frame, but the turnaround time is ultimately dependent on the time of year and business volume.

Why not add some artistic effects to a few images prior to presenting them to your clients? This will give them a clear idea as to how their favorite images can be further enhanced and customized. Photo by Vicki and Jed Taufer.

IMAGE MODIFICATION FORM

First and last name: _____

Session date: _____

Session location: _____

PHOTO MANIPULATION

IMAGE NUMBER	TECHNIQUE USED
_____	_____
_____	_____
_____	_____
_____	_____
_____	_____

STATUS TRACKING

ACTIVITY	PERFORMED BY	DATE
Image modification		
Images Online		
Stock Photos Ordered		
Work Folder CD Burned		
Prep 4x5-inch Image		
Send Thank-You Note		

STOCK PHOTO ORDER

VENDOR	IMAGE NUMBER AND SIZE
_____	_____
_____	_____
_____	_____
_____	_____
_____	_____

ACTIONS

Actions are programs that work in Photoshop and allow users to automatically apply commonly required image enhancement processes, saving time and energy while ensuring the portrait quality they demand. Photographer Craig Minielly has developed a wide variety of custom actions that allow photographers to control color, retouch and add softening effects, make creative enhancements, and complete all the steps necessary for print and image file output. He typically makes use of a number of actions for each image, as you will see in the text that follows. Using these actions on the average image it generally takes just a few minutes for full, corrective retouching. For a wall-size portrait the process takes no more than ten minutes, yielding a creatively enhanced image with full effects and backup files.

On the following pages, we'll look at how he captured an image of his subject, Sara, and how he used some basic Photoshop manipulation plus his actions to finesse the final portrait. All of the actions described below can be purchased at www.craigsactions.com.

Capture. Sara was positioned so that the natural light was coming in from her left. The setting was amazing, with Spanish moss everywhere and the diffuse light breaking through it. A Nikon SB-800 AF speedlight supplemented the light. Craig feels that even at its lowest settings, it provides just enough clean light to brighten up the eyes and allows him to easily enhance them in postproduction.

Whether he shoots JPEG or RAW, Craig turns off the in-camera sharpening and sets the tone to low. These settings provide him with the best tonal range with minimal areas needing retouching for exposure.

Color Enhancements. To enhance the portrait's tonality and color, Craig applied the Portrait Popper action (from the StoryTellers Two, vol. 5 actions set). This snapped the colors back into place with nicely balanced neutrals, extra punch to the shadows, clean highlights, and very pleasing overall color. He may slightly modify the image's color and brightness later, but this action generally provides the necessary color adjustments.

A Better Composition. Craig felt that tipping Sara's head more to the left would create more visual balance. Because the background was so easy to work with, this was best accomplished by creating a loose selection (feathered 10 pixels) around her head, including some of the greenery. To create a new layer containing only the selection he went to Layer>New>Layer via Copy. He then went to Edit>Free Transform and rotated the image into place. Next, he created a mask via Layer>Layer Mask>Reveal All and worked with a black brush to selectively brush out the telltale edges of the transformation. (Craig typically clones out and tones down distracting background details before making any further adjustments or image manipulations.) Finally, he flattened the image. (Note that head swaps are not always quite this straightforward!)

Craig felt that tipping Sara's head more to the left would create more visual balance.

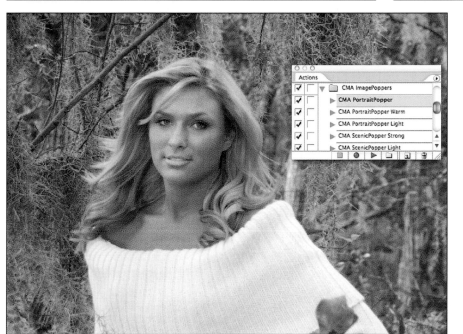

Top left—Original image, captured with a Nikon D200 (f/5 @ 1/90 sec., 320 ISO) and a Nikon 18–200mm f/3.5–5.6 lens used at 55mm. Craig selected the following camera settings: JPEG Fine mode, white balance set to flash, aperture priority mode, exposure compensation: +.7EV. His Nikon SB-800 AF speedlight (exposure value of –3.0) was used to supplement the ambient light. Top right—Final image. Left—The enhanced image, showing the one-touch color control provided by the Portrait Popper action.

Top—Image with feathered selection containing enough foliage for easy blending of the rotated area. **Bottom**—The selected area (on a separate layer) was rotated, and the edge details were blended in using a layer mask.

Putting On the Best Face. Next, Craig typically works to undertake any required cosmetic retouching. Sara's complexion wasn't problematic, so he used the Clone tool in the Lighten mode at 30% opacity to even out the darker areas under her eyes. He then ran the Facial Enhancements action (in Productivity Essentials, vol. 1); this set up the control layers so he could go in and brush the enhancements into the eyes, teeth, and even the lips. Mod-

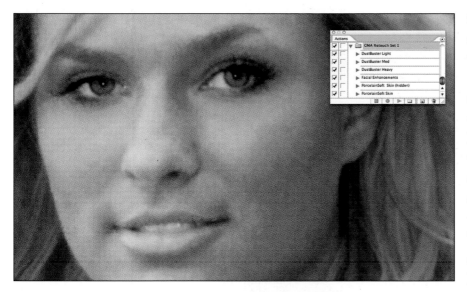

ifying the eye color is simple; you can set it to any shade you want at any time with the built-in control layer.

Sara's skin is almost perfect. However, Craig runs the ShadowSoft (ShadowSoft & Grainy, vol. 2) or PorcelainSkin (Productivity Essentials, vol. 1) action (or sometimes both) on every image. This gives him additional creative control for producing selective softness throughout the image. They're easily modified for any subject and setting, and perfect for when you have more than one person in the image as you can selectively brush the detail in or out with the built-in masks, and still adjust the overall opacity of the soft layer for final control and effect. The ShadowSoft actions allow you to choose options for color, contrast, black & white, and grainy effects.

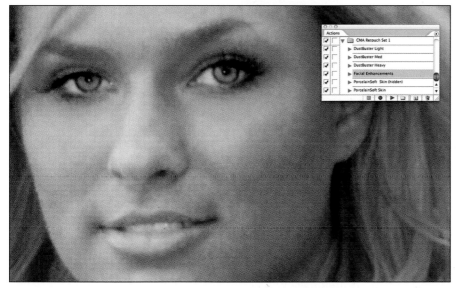

Craig likes to run the PorcelainSkin action and have it stop at the Gaussian Blur step, so he can adjust the value to ensure maximum softness without "blurring out" the mid-shadows and losing their detail.

Craig says, "That's it for the regular production on this image. As mentioned earlier, it takes no more than a couple of minutes. I always save my cropping and final sharpening until the last stage so I can maintain full control over how the image will be presented."

Top—Image before the Facial Enhancements action was applied. **Center**—Image after the Facial Enhancements action was applied. **Bottom**—Image after the Facial Enhancements action was applied, showing the use of additional controls for eye color.

Top—Image before applying the PorcelainSkin action. **Bottom**—Image after PorcelainSkin action, and with selective details brushed back in using the mask on the Soft Control layer.

Creative Enhancements for Maximum Impact. The Fashionizer actions (in StoryTellers One, vol. 4) produce an edgy effect that works well with teen and senior portraits. It is fabulous on fine-art prints and press photographs, as it allows details to rise up where they would normally bleed out and be lost.

Various controls allow you to scale back the intensity of the effect and brush it in or out wherever you want. If the effect seems overpowering, you can adjust it to achieve just the look you want to create.

Top—Almost completed image, prior to running the Fashionizer action. **Bottom**—The image with the Fashionizer Strong action applied. The image has a cool, edgy look that will print beautifully and have great appeal to younger clients. The effect can be scaled back and selectively applied or removed to suit your tastes.

Final Touches. To complete Sara's image, Craig applied the Unsharp Mask action (Productivity Essentials, vol. 1). He runs this action on every image after all sizing and cropping is complete. All of the sharpening actions

in these sets have built-in (and automatically handled) luminosity adjustments to ensure the maximum quality of detail without introducing any stray artifacts or pixelization.

Top—The portrait before final sharpening was applied. Bottom—Important subject details were brought back with the Unsharp Mask Heavy action.

9. Album Production

Photojournalism was once the sole domain of the wedding industry, but this candid style has made its way into children's and family portraiture. Now, more and more studios are capitalizing on the concept of portrait photojournalism—documenting a day or a year in the life of the client or, in some cases, following a client as he or show grows over the course of many years. This documentary-type portraiture is very popular for newborns or to chronicle the events of graduation day, and it is also a big hit with grandparents. This change has made children's and family albums more popular than ever!

Among the most popular albums are Day in the Life books, which chronicle the subject's activities from morning to night, and the Treasured Moments montage album, a collage-style album that is also narrative in nature but utilizes a longer time frame to tell the story.

Some photographers have turned away from wedding photography, as sales of their children's and family portrait albums have substantially padded their incomes! Let's imagine that a mother purchases a five-session Treasured Moments plan. This portrait plan will cost $2,000, and she will need to pay $400 at the end of each of the five sessions. If you spend an hour on each session, you can see that this can be lucrative.

Portraits that document your subjects' interests can work well in any album. Remember that with digital imaging, there are a wealth of imaging opportunities at your fingertips. Note how the mood of this image was dramatically changed by adding a simple sepia tone. Photos by Craig Minielly.

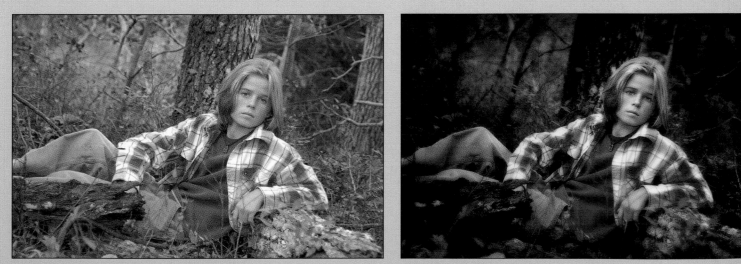

With the awesome advancements in technology, you can easily send an album order to the lab on the day of the client's session! These advancements have expedited our workflow tremendously. Our clients are pleased, and their friends are amazed.

To make album production a lucrative venture at your studio, utilize the production tips in chapter 8 and consider the points made below.

LAB RELATIONSHIP

Contact your lab and ask to speak with a digital developing specialist. (A customer service representative cannot help you with the process!) You need to establish a strong relationship with the person retrieving and printing your files. They need to understand your style, and you must be able to contact them when you are experiencing challenges. If the customer service rep will not allow you to speak with the specialist directly, consider searching for a lab that offers more personalized service.

You need to establish a strong relationship with the person retrieving and printing your files.

MONITOR CALIBRATION

Ask the digital developing specialist at your lab to send you a test file—preferably one you can download—along with a test print. You will use this test print to match up your monitor (displaying the test file) as closely as possible with the print. After matching it up, send them a file of your own to find out whether the print they make from the file matches what you saw on your monitor. If not, you will need to use the steps outlined below to calibrate your monitor.

Don't let the calibration process frustrate you. This is one of the most difficult yet crucial steps in the digital production process. If you try the following suggestions and are still experiencing conflicts, then consider hiring someone to come in and calibrate your monitor for you. Alternatively, you can select a lab that handles calibration as part of the printing process.

When you open an image on your computer, a numerical value should be assigned by the computer to each pixel (red, green, blue). If these values are not defined, then there is no standard by which the image can be viewed from computer to computer. The control system used to identify the numerical values of colors is called color management. This creates workflow consistency.

Most monitors are calibrated to produce accurate colors, but a variance may occur based on the hardware and computer systems being used. Often, a variation occurs from studios to labs based on what color mode your lab is working in. For instance, we had a calibration issue when our lab switched from RGB to sRGB mode. To prevent problems, develop a strong relationship with your lab. Stay in touch with the person who is working with your digital files. The constant communication and personal relationship is important.

CALIBRATION TERMS

Here are a few terms you're likely to encounter when reading literature on processing your digital images.

Color correction. The adjustment of the brightness, contrast, and color balance in an image so that the colors are rendered as desired.

Gamma. The brightness of the gray tones in an image. Adjusting the gamma tones brightens or darkens the midtones of the image.

Monitor resolution. The number of pixels per inch that the monitor uses to display an image.

Implementing a filing system will ensure that images are easy to retrieve for special projects like a portrait panel. Photo by Jeff Hawkins.

Adobe provides a tool with Photoshop (for Windows-based system users) that allows consistent color from monitor to monitor to be carried out with calibration and profiling. This tool is called Adobe Gamma. Many studios find this to be sufficient for all of their calibration needs. However, the human eye is not always the most precise measuring device and is especially dependent on unchanging light conditions. Therefore, some studios prefer to use software that allows a hardware device to be used for measuring and recording a range of colors. The data is then saved in a profile to describe the color capabilities of the monitor. We recommend using GretagMacbeth's EyeOne to easily create an accurate profile for the monitor. It works on both CRT and LCD monitors with both Mac and PC platforms. Another helpful tool for Mac users is ColorSync (www.apple.com/colorsync). It is designed to ensure powerful color management with every application.

THE FOUR-STEP FILE PREP PROCESS

There are four distinct final steps that must be accomplished to prepare your images for output—file organization, color correction, retouching, and cropping. Each phase is discussed in detail below.

Step 1: Organization. Once you are comfortable with your relationship with the lab and satisfied that your monitor is correctly calibrated, you can initiate the image ordering process by applying the file prep system and retouching process.

To begin, highlight the different image sizes on your client's order form. For instance, highlight the 3x5-inch images in pink, the 5x7-inch photographs in green, and the 8x10-inch shots in blue. This system will make cropping easier and more efficient. Next, complete the following steps:

There are four distinct steps that must be accomplished to prepare your images for output.

1. Copy the images from your client's CD/DVD into a folder on your hard drive, then create a subfolder called "file prep."
2. In this folder, create subfolders for various image sizes (5x7s, 8x10s, etc.).
3. Next, copy the files to be printed as 3x5-inch prints into the corresponding folder. Repeat until all of the image files are moved into the appropriate folders. *Note:* If the client has ordered multiple copies of the same pose, move the original file into the 8x10 folder and then copy it into the folders that correspond to smaller image sizes. Please keep in mind that as technology continues to change, more labs are developing systems and software to expedite this process. Continue to evaluate the processing time that completing this task requires versus the cost of software, which may expedite the process.

Step 2: Color Correction. Once the files have been moved into the appropriate folders, you should use Photoshop to color correct each of the files.

The two most commonly used tools for correcting color are Levels and Curves. The Levels feature is easier to learn and is a good beginning tool. However, Curves will offer you more control, allowing you to achieve better contrast and skin tone. Remember when using either of these tools, less is often more! No matter which option you choose, you should follow up with an adjustment to the color balance as well.

Levels. In an image with a good range of tones, the histogram will fill the length of the chart (i.e., it will have dark shadows, bright highlights, and everything in between). In a good portrait, the pixel density (in the output levels) should be close to zero on the left (shadow) side and about 250 on the right (highlight) side.

To enhance an image that needs a little help, follow these simple steps:

1. Open an image in the file prep folder.
2. Go to Image>Adjustments>Levels.
3. To adjust the black and white point in the image, we'll first work with the two sliders in the Output Levels field. Move the slider on the left to adjust the shadow to your liking (this usually looks nice at about 5), then move the slider on the right to adjust the highlights to your liking (this usually looks good at about 250).
4. To adjust the pixel distribution, we'll turn our attention next to the Input Levels. If the image is too dark, move the center slider (under the histogram) to the left. If the image is too light, move the slider to the right. This center slider represents the midtones in the image.

Curves. As noted above, using the Curves function is more complicated and requires more practice. However, skilled users consider it the tool of choice for making precise color correction.

Top—Create subfolders for each print size to simplify the ordering process. **Above**—Photoshop's Levels feature is one of the most popular tools for making color corrections.

BRIGHTNESS/CONTRAST

The Brightness/Contrast function can also be used in the color correction process. To use it, go to Image>Adjustments>Brightness/Contrast, then adjust the sliders until you achieve the desired result. Use this tool sparingly, as repeated use on a single image can cause a loss of detail in the highlight and shadow areas of your image.

The Curves feature is the best choice for making precise color adjustments in your images.

When you open Curves, you'll see a dialog box containing a grid with a diagonal line running from the bottom left to the top right of the graph. This line represents the tones in the image, with the bottom left point being the darkest shadow and the top right point being the brightest highlight. By clicking on this line, you can add handles and drag the line up or down. By adding multiple handles, you can drag the line into an S-shaped curve. For the most natural-looking results, be sure to keep the bends in the line as small and smooth as possible.

In the steps below, you will also use the black point, gray point, and white point eyedroppers. These are located near the bottom-right corner of the dialog box. As their names suggest, they are used to manually select the black, gray, and white points in an image.

1. Open an image in the file prep folder.
2. Go to Image>Adjustments>Curves.
3. Click on the center of the diagonal line and move it up (lighten) or down (darken).
4. Select the black point eyedropper, then click on the darkest point in the image.
5. Select the white point eyedropper, then click on the lightest point in the image.
6. Select the gray point eyedropper and click on a midtone in the image.
7. Adjust to your liking and continue to practice this technique until you are satisfied with your results.

Color Balance. The final step in the color correction process is to use Photoshop's Color Balance feature. This will finalize the color corrections and prep your image for printing.

1. Open an image in the file prep folder.
2. Go to Image>Adjustments>Color Balance.
3. You will see three different sliders: Cyan/Red, Magenta/Green, Yellow/Blue. Adjust each of the sliders until you achieve an appealing color balance.
4. Once the results are to your liking, hit OK and save the image.

Left—In Photoshop, select Image>Adjustments>Color Balance. **Above**—Adjust the sliders until you achieve a pleasing color balance across the image. By selecting the shadows, midtones, or highlight button, you can limit the tones that will be affected in the image.

Step 3: Retouching. The next phase of the file prep process is retouching. The easiest tools to use for retouching purposes are the Clone tool and the Healing Brush or Patch tool.

The Lasso tool allows you to make a selection in order to remove an object. For example, imagine you have a photograph showing a light switch that you want to conceal.

1. Open the image.
2. Identify another area in the photograph where the image data could be used to cover the problem area. The selected area should have the same lighting condition as the area being covered. This will reduce the need for blending.
3. Select the Lasso tool and trace around the area to be used to conceal the problem.
4. Copy this area (Edit>Copy) and paste it onto a new layer (Edit>Paste).
5. In the Layers palette, activate the new layer containing the "patch" and move the copied material into position over the area to be concealed.
6. If needed, use the Healing Brush to blend the edges.
7. Flatten (Layer>Flatten Image) and save the image.

The Healing Brush and Patch tools were introduced in Photoshop 7. They have revolutionized photo retouching in that they reduce the time spent retouching blemishes, wrinkles, and similar problem areas in your subjects. Like the Clone tool, the Healing Brush allows you to sample an area (Alt/Opt + click), then paint it over a flawed area of the image. Since it samples about 10 pixels, users may notice a bleeding effect. To prevent this problem, use the Lasso tool to select only the desired area, then apply the sample inside the selected area.

The Patch tool is used in a similar manner but works best for correcting larger problem areas. The Patch tool is easily located by clicking on the arrow to the right of the Healing Brush icon. With the tool selected, make a selection of a suitable replacement area, then apply the selection over the unwanted element. In some cases, you may want to use the Clone tool or Healing Brush to blend the edited area into the original image. Step-by-step guidelines for using these tools follow:

1. Open the image.
2. Select the Healing Brush or Patch tool.
3. To select an area from which to sample, move your cursor over the area, press the Alt/Opt key and click. This selected area should match the tone and texture of the area to be retouched and be as close to it as possible.
4. Click on the area to be retouched.

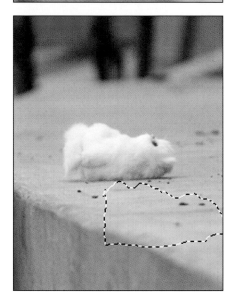

The Patch tool can be used to copy replacement image data over a problem area. This works best with larger problem areas, and some blending may be required in order to make the retouching invisible.

5. Repeat steps 4 and 5 until the problem is corrected and looks natural. If necessary, hit Edit>Undo to immediately reverse any change that looks bad (or undo multiple steps using the History palette).
6. Save the image.

Keep in mind, these tools represent only two basic options for retouching your photos. Begin with these steps to eliminate flaws and remove imperfections. Keep your options open; there is a world of possibility at your fingertips, and practice makes perfect.

Step 4: Cropping. Once the images are placed in the appropriate folders, you will need to crop the image files to the desired dimensions. Cropping allows you to frame the image based on the aspect ratio of the desired print size. When using photo manipulation software, it is important to remember that there are many different ways to accomplish a single task. Always use the techniques with which you are most comfortable. Here are a few suggestions:

1. Open an image in the 3x5-inch (or another image size) subfolder.
2. Select the Crop tool.
3. In the Options bar, enter the desired image dimensions (in this case, 3x5 inches). Set the output resolution as recommended by your lab.
4. Drag the Crop tool across the image (the marquee will automatically measure 3x5 inches, or whatever dimensions you entered in the Options bar). Simply drag the marquee up or down or to either side to ensure no important image detail falls outside of the marquee.
5. Hit the Enter/Return key to crop the image, then go to File>Save.

Remember that there are many different ways to accomplish a single task.

Photoshop's Crop tool can be used to improve compositions, eliminate distractions, or simply resize your image to achieve different print dimensions. Note that the dark area outside of the selection will be eliminated when you hit the Enter/Return key.

PREPARING FILES FOR THE LAB

Once the images have been color corrected, retouched, and cropped, the files are nearly ready to be sent to the lab for output. There are a few more concerns that need to be addressed.

Rotate to Vertical. Our lab requires that all of our images be rotated vertically. This may be different for you. If your lab requires vertical images, follow these steps:

1. In Photoshop, open a horizontal image.
2. Go to Image>Rotate Canvas>90° CW (clockwise) or CCW (counterclockwise).
3. Save and close the image.

File Format. Our lab requires that our images be saved as TIFF files. Changing the file format can be easily accomplished:

1. Open an image in Photoshop, then go to File>Save As.
2. Under format, select TIFF, then hit Save.
3. A second dialog box will then appear. In it, select the byte order that your lab prefers (IBM or Mac). Do not use the LZW compression option. Click OK and close the image. (*Caution!* To avoid printing low-resolution images, remember to delete your JPEG images before sending the files to the lab!)

Burn a CD/DVD. When all of the above image modifications are complete, burn a CD/DVD, send it to the lab, and wait for the final prints. When your prints are returned, they will most likely be numbered. All you will have to do is cut and mount them, then present them to your clients!

Alternatively, you may want to check with your printer to see whether you can send files via FTP (file transfer protocol), allowing you to send a finished file to the lab via the Internet. With this option, you won't need to burn a CD or pay for postage to ship your files to the lab. It also expedites your production process, as the files are immediately available to your lab with the click of a button. Just be sure to contact the lab to make sure that your files were received!

CREATING NARRATIVE ALBUMS

Many photographers are using the Day in the Life or Treasured Moments montage concept to create digital album designs. You can use template software or use Photoshop to create your own distinctive templates. We have found that making your own templates is generally quicker and easier than searching for the right template to accompany the selected image files. Here's how it's done:

Above and facing page—Maternity photos can make for a cherished part of an heirloom quality album. Photos by Jeff Hawkins.

RESOLUTION REQUIREMENTS
Typical resolution requirements may be 250ppi for files going to the lab, 300ppi for offset presses (printing for books and magazines, for example), and 180ppi for inkjet printers.

To begin, open a document of the desired size in Photoshop. Use guides to define your work area, leaving at least ⅛ inch on each edge for margins. Next, open the images you intend to use, then click and drag each image into the document using the Move tool. You can then use the Transform tool (cmnd + T) to reduce the image size to allow more room on your desktop. (If you click the Shift key while adjusting the image size, the aspect ratio will be maintained.) Additional guides can be used to ensure precise image placement.

Background Design. To design a complementary background, create a background layer copy, then fill in the area with a color that harmonizes with the chosen images.

You can instead use an image to fill the background. Just drag an image into the background area, resize it, and adjust the opacity (in the Layers palette) to fade the image.

Finishing Touches. There are other ways in which the template can be further enhanced. Here are a few ideas:

- To create a border around an image, create a background layer copy. Then, go to Edit>Stroke and set the stroke width at about 8 pixels. Click on the color box to activate the Color Picker and select the color you want your border to be (the foreground color is the default setting). Click OK and save the image.
- To add a drop shadow to an image, double click on the layer thumbnail. This will bring up the Blending Options dialog box. Double click on the drop-shadow option in the left-hand side of the dialog box, then set the distance, spread, and size of the effect in the right-hand side of the window. Click OK, then save the image.

Trust in the Lord

with all your heart...

and He shall

direct your path

Above and facing page—Creating stunning album pages is easy with some basic knowledge of Photoshop. Photos by Jeff Hawkins.

• You can add text to your image and bevel, emboss, or add a drop shadow to it as well. Always consider color harmony when selecting a text color. Also, be sure to select an easy-to-read type style.

Saving Your Work. With the effects in place, save your work. Do not flatten the layers yet in case you want to make changes later. If you plan to e-mail the flattened image to a client, resize it to 5x7 inches at 72dpi, select Save As, rename the file and extension, and save the image in a folder named "e-mail."

Suggested Proofing Policies. Now it's time to present the proofs to your clients. The following steps will help you make the most of this experience.

1. Meet with clients to go over images or place the images online for your client's convenience. Be sure to send a follow-up e-mail that outlines the viewing process.
2. Once the client has identified the image numbers he or she would like to order, prep the images and place them in a work folder.
3. Complete any digital enhancements and send the client's proofs and instructions, noting the balance due, if applicable.
4. Before the previously established deadline, the client should bring up any retouching requests they have. Once the changes are made, a second proof should be sent to the client.
5. Once written approval is received from the client, the book is sent to the album company.
6. At this point, we send a copy of our order/instruction form to the lab and place a copy of the form in the client's file.
7. The client's album is then placed in our tracking system.

11. Tips from the Pros

Frank Donnino
Frank Donnino Photography
Boynton Beach, Florida
www.frank.nu

From his humble beginnings in his Long Island, New York, home studio in 1980 to his present studio location in the Palm Beach area, Frank Donnino has continuously studied his craft and spares no expense to do so. He has been privileged to study with some of the top photographic talent throughout the world, who have shaped the very fabric of what Frank creates to this day.

Frank is a proud member of PPA and the Florida Professional Photographers. His willingness to share his knowledge with photographers throughout the world is his joy and passion. He has been a keynote speaker at seminars across the country and has taught the techniques he uses for his photography and studio operations to photographers from all over the globe. Frank asserts that a photographer's talent is a "borrowed" gift that must be used for the greater good and should be shared.

Digital History. Frank says, "Digital has had an incredible impact on our business. What would have been impossible a few years ago has become a reality. We can make people look their very best, and it's cost effective to do so. Like anything else, change takes some getting used to. We have a great workflow now and can process files for the lab in a reasonable amount of time. Gone are the days of working all day and night just to get the job done."

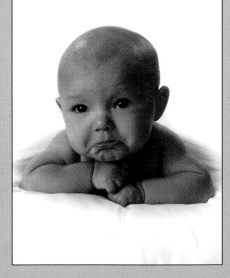

Photo by Frank Donnino.

Frank currently captures his images using the Canon 1DS and Canon 20D with 70–200mm and 28–70mm zoom lenses. Shooting digitally allows Frank to quickly edit and enhance images and create products that would not have been possible with film. With digital capture, the storage and retrieval of images is easier also. If he wants to find an image he shot for a client in 2003, he doesn't have to go through boxes of negatives; he can go into his image archives and find the file in minutes.

Tantalizing Tip. Frank has created an impressive coffee-table book called *Beyond the Glow*, which showcases his pregnancy photography. He places these books in Ob/Gyn offices across his marketing area to try to get women into the studio for maternity portraits and later, children's and family images.

Popular Products. The "Kissables" collection—a series of nine close-up photographs of the eyes, ears, nose, etc., presented in a 16x16-inch frame—is Frank's most popular product. He says, "It has a very strong appeal to new moms, who love to see the special features of their baby that cannot be captured on their own. We have also had great success with a 5x30-inch panel of different photographs from a session. These products are only possible with digital technology as they can be easily sized and configured. If you can imagine it, you can create it!"

Hot Marketing Idea. We give every client a photo "diaper bag" tag and photo key ring when they come in to view their images. We also give them business cards that feature an image of their child, which they proudly hand out to their friends and family. It's an easy way to generate business.

These products are only possible with digital technology as they can be easily sized and configured.

Sherri Ebert
Sherri Ebert Photography
Jacksonville, Florida
www.ebertimages.com

Sherri Ebert owns a small wedding photography business in Jacksonville, Florida. She has been photographing weddings since 1988 and finds herself doing more and more children's and family sessions as her clients are starting families. Sherri says 95 percent of what she shoots is on location—either at the beach, at a home, or park—anyplace that is special to her client.

Sherri defines her photographic style as loose and free. She doesn't like to pose her subjects; instead, she merely guides them. She wants to capture their real personalities, not a stiff, uptight, fake-smile, posed image. This is a style that appeals to the judges, too, as is evidenced by the fact that she's received the Becker Award for Creative Photography 2002; Best of Show 2002; People's Choice Award 2002; First Place Portrait Album; Fuji Masterpiece Award; First-Time Album, and Florida's Top Ten Award, all from PPA.

In addition, Sherri recently received a First Place Award for Informal Non-Event Album and has an album in the PPA Loan Collection.

Digital History. Sherri shoots 100 percent digitally. She currently uses the Canon EOS-1D and says, "You couldn't pay me to go back to film! No way!"

Advantages. Sherri believes there are pros and cons to going digital. However, for her, the advantages far outweigh the disadvantages. She admits that the ability to retouch images digitally has had a huge impact on her business

and the quality of her work. It allows her to offer her clients a number of options, including special effects, specialized photographic edges, and instant conversion from color to black & white if she so desires. She says, "The retouching I do was not feasible with film; not only was it extremely expensive, but it was never to the quality I expected. With digital, just one file has to be retouched, then you can print as many copies as you wish."

For Sherri, shooting digitally is especially well suited to photographing children: "Digital technology comes in handy when you are photographing moving targets like children. When you are chasing around two-year-olds, who only pause for a millisecond, waiting for proofs is stressful. With digital capture, it's still hard to chase around two-year-olds, but at least you know right then and there whether you got the image or not!" The instant feedback is priceless, allowing photographers to correct white balance and exposure settings and proceed through the session with confidence. If an image isn't quite right, all you have to do is delete it; you no longer need to line your wastebaskets with expensive proofs.

Photo by Sherri Ebert.

Some other advantages Sherri has found since making the switch to digital include: being able to shoot more images and get more great shots for her clients; not having to juggle multiple cameras and stop to reload film (e.g., color, black & white, infrared); and the ability to produce proofs quickly and via a variety of means (e.g., projection displays, on-screen, on the Internet, or with contact sheets).

Tantalizing Tip. Sherri says, "I really like funky edges. It's something different, something special. I really like watercolor effects and adding soft focus after the fact, only where I want it. My advice (only with children) is to capture the image as sharply and with the greatest depth of field as you can! You can always soften the image later."

Popular Products. Sherri's studio offers albums from Art Leather, Albums Inc., and Zookbinder. She prefers the look and feel of the flush-mounted albums and the photojournalistic album concept. Says Sherri, "I like to do 'series' portraits of kids—three or more images in the same frame that show the action of a child doing something interesting. I like close-ups of the actions. I also create a lot of what I call 'collage portraits,' usually nine or more images that, together, make an interesting composition."

Hot Marketing Idea. Sherri advises other photographers, "Create a vision, be unique, and share your ideas with your client. Try wacky, crazy stuff just to see what you can get. Sometimes you end up with beautiful, happy accidents. Those 'accidents' can be priceless!"

Jeff Hawkins
Jeff Hawkins Photography
Alamonte Springs, Florida
www.jeffhawkins.com

Jeff Hawkins is an award-winning, PPA Certified photographer and holds a Photographic Masters degree. He has been a professional photographer since 1980 and operates an upscale wedding and portrait business in Central Florida.

Digital History. Jeff was the first photographer in Central Florida to take the digital leap and readily embraces all the technology and software at his fingertips. As a Canon Explorer of Light, Jeff photographs with the Canon 5D.

Advantages. Jeff says, "With digital, we don't have to count exposures. We believe in photographing children when they don't know we are taking the photo. We capture at least 150 images per session. These are edited down, of course, but capturing a wide variety of images allows us to sell more."

The main advantage to working digitally is the ability to offer online ordering. Once the clients have viewed their images and placed their orders, the images are uploaded and can be viewed by their friends and family. "We use www.eventpix.com, which creates a link through our website. It is mainly a public relations tool and drives people to the studio website, which ultimately increases sales. It is an awesome form of studio exposure!" says Jeff.

Tantalizing Tip. "Use Nik Software's Color Efex Pro! and Craig's Actions. These great programs will give your images a unique creative look."

Popular Products. "We sell many of the multiple-image wall folios by Gross National Product to our baby portrait clients. Our Lifetime Portrait Program members typically get the Seldex nine-inch gallery album or the Cache narrative album by Art Leather.

Hot Marketing Idea. Jeff has learned that making connections with local business professionals can mean an increase in sales. He advises, "Create a solid business relationship with upscale local physicians, interior decorators, or new home development managers." When businesses hire you to take their PR photos, you can form a mutually beneficial promotional campaign. For instance, by offering gift certificates to a businessperson, they can offer them to their clients as a thank-you gift. The gift certificate translates into extra income when your new clients sit through a session and buy your images.

Presentation is important to your studio's image. To deliver the gift certificate with style, Jeff recommends using Emotion Media Inc. (www.emotionmedia.com) to create a digital collage of your work, set to royalty-free music, and recorded on a CD. They will place the CD in a beautiful CD folio for a minimal investment. The CD and folio are returned when they redeem the gift certificate and can be reused."

Photo by Jeff Hawkins.

Joann Muñoz
Muñoz Studio Photography
Ft. Lauderdale, Florida
www.munozstudios.com

When Joann Muñoz married Master Photographer Mario Muñoz in 1980, she married not only into his family but also into the family business, which has been around for over 90 years. Upon their marriage, her husband began teaching her the business. Joann loves children (Joann and Mario have four) and soon realized her love for photographing kids. She now specializes in the studio photography of babies, children, families, couples, and maternity images.

Joann has nineteen merits with PPA and is a Certified Photographer. She was awarded First Place at the Florida State Convention in the Portrait of a Couple category and won Third Place in the group portraiture category in 2002.

Digital History. Joann made the transition to digital in 2001 and has experienced no disadvantages in making the switch. She is currently photographing with the Canon 1DS Mark-II.

Advantages. To Joann, the biggest advantage digital photography offers is instant gratification. "Seeing the shot immediately and being able to correct problems right away is a huge advantage," she says. Another advantage is being able to manipulate and retouch the images quickly in the studio and print any rush orders immediately if needed, "Charging a rush fee, of course," Joann explains.

Together with her daughter-in-law, Erika Muñoz, Joann captures the Watch Me Grow baby session and boudoir images for their studio. They love capturing portraits side by side and believe that their ability to create the images they see in their imagination is a real advantage for their clients. Their customers enjoy being able to order their images right away. Another benefit, says Joann, is that with digital capture, the turnaround time for even non-rush jobs is much faster than when shooting negatives. She emphasizes, "Our Epson 9800 doesn't stop printing until December 23rd. Yes, we will do a last-minute job—no problem!"

Tantalizing Tip. "Work with Photoshop to design your image very artistically. Being different is important, because you are putting yourself into the image, and no one is like you," Joann says.

Popular Products. One of the Muñoz studio's most popular products is their portrait panels showcased in a Gross National Product (GNP) frame. However, today's technology

Photo by Joann Muñoz.

also allows Joann and Erika to create tasteful boudoir portraits, which are featured in their popular For Your Eyes Only album. Joann says it pleases the women's husbands to know the images were made by women, and that posing for female photographers makes most of the subjects feel more at ease. She also notes that digital imaging allows her to enhance the images in a way that was never before possible.

Hot Marketing Idea. The studio's Watch Me Grow program, which includes an album, is one of the hottest marketing strategies (they give credit to Bruce Evenson). Joann explains, "Our Watch Me Grow program begins at the maternity session. We photograph the mother when she is about eight months pregnant. The second session is held when the baby is two weeks old, and the infant is photographed with Daddy. Mom can also participate, but we suggest she wait a month. After that, the baby is photographed monthly in a different scenario, since the baby changes the most during the first year. At the end of the year, the client receives an 8x8-inch designer album composed of the best images, arranged in a chronological sequence, so you can watch the child grow.

> Digital imaging allows her to enhance the images in a way that was never before possible.

Craig Minielly
Aura Photographics
Vancouver, British Columbia
www.auraphotographics.com

Craig is a Master Photographer and is PPA Certified. He has been awarded multiple Gallery, Masterpiece, and Loan Collection Awards, all from PPA. He has been a studio owner for over twenty-five years and caters to commercial editorial and portrait clients. He currently captures images using the Nikon D2X and D200, Nikon SB-800 AF speedlights, Quantum Turbo 2+2 battery packs, and AlienBees strobes. He uses Tamrac gear bags to carry it all.

Advantages. Craig says, "Today's technology strives to emulate film techniques that revolved around in-camera manipulations of light and color, as well as darkroom techniques to expand material limitations and creative possibilities. Ironically, many 'technological advances' replicate historical artistic practices. The ease and repeatability of these processes has resulted in a more effectively marketed service and image options to be presented to our clients. This new simplicity of operations also provides time for further creative image explorations. It's a great time to be a client, as there is a whole new world of artistic and imaginative possibilities of creating and presenting images.

It's wonderfully empowering to present the images we've created together and see the emotional response that they elicit. My image organization and editing is effectively accomplished with Photo Mechanic (www.camera

bits.com). The whole project is then moved into Apple's Aperture, where my initial and overall image adjustments are made. I bring the selected images into Photoshop and use a variety of my own actions (www.craigsactions.com) to make all of the retouching and creative enhancements necessary in order to bring the images to life. I often also use the Power Processor Proofing actions and create a proofing presentation with ProShow Producer (www.photodex.com). iView Media Pro is also regularly used for editing and cataloging applications."

Tantalizing Tips. Craig consistently uses the aperture priority and autoexposure modes on his Nikons. He complements this approach with the use of the exposure compensation dial to fine-tune the final exposure. Craig says, "I like to think the aperture priority mode will produce a good starting exposure for my setting, and I use the exposure compensation to expose for the subject. I can add strobes, filters, or polarizers to my setup without making confusing exposure recalculations, so I can concentrate on my subject rather than on my camera setup."

Popular Products. Aura Photographics' most popular products are the wall art prints and canvases that are now so easily created. Craig states, "The vibrancy and tonality of the images on screen are now beautifully and effectively rendered to fine art papers and canvases." Hahnemuhle is Craig's favorite source for both canvas and papers. He believes the consistency among their surfaces and quality of their products is second to none.

Photo by Craig Minielly.

Hot Marketing Ideas. Craig prefers the term "presentation guide" to the more common "price list." He has a separate area for his portrait enhancement fees. When clients elect to pay this fee, they can enjoy multiple retouched prints, in a variety of sizes, all for one price. They do not feel like they have to purchase from a premium print or signature print category to have fully retouched images. This results in greater sales and revenue from every session, and the client feels they have far more value from their session.

Vicki Popwell
Vicki Popwell Photography
Andalusia, Alabama
www.vickipopwell.com

Vicki Popwell is a Master Craftsman Photographer and is PPA Certified. She is an Approved Photographic Instructor through PPA. She is a member of PPA, WPPI, and ASP and is a popular speaker on kids' and family portraiture. Vicki is a member of the FujiFilm talent team and has written many articles on photography.

Digital History. Vicki created portraits with the Hasselblad camera and Fuji film for many years. In 2001, she made the transition to digital. She now has a Fuji S3 camera with a Tamron lens, White Lightning lights, and an Epson printer—and she loves it! She purchased Photoshop about seven years ago and believes that learning Photoshop is essential for photographers transitioning from film to digital.

Advantages. "Certainly one of the advantages of digital capture is the ability to quickly see and print your captured image. Also, the price of a quality digital camera has dropped drastically, making it more affordable for most photographers," says Vicki.

Vicki believes that a favorite quote, "The real voyage of discovery lies not in seeking new landscapes, but in having new eyes," aptly describes the potential that going digital offers. Going digital has allowed her to investigate all of the options at her fingertips. When she views an image, her imagination runs wild—she can render the image in color or black & white, in a sepia tone, or as a panel image, and can even produce watercolor note cards. These many options are creatively satisfying for Vicki and please her clients as well.

Tantalizing Tip. Vicki recommends marketing your work with simple ads. She believes that one strong image is better than too many images in an ad. She also recommends using the same logo, colors, words, etc., to gain recognition (branding) of your studio and your work.

Photo by Vicki Popwell.

Popular Products. Vicki's studio sells lots of frames, from small easels to large 40x60-inch types. Panels are also popular at the studio. Prior to going digital, Vicki printed and toned her sepia photos, then personally mounted her images. She then hand-painted the images with traditional oil paints. The process required a great deal of time and a lot of painstaking work. With digital photography, she can produce beautiful full-color, black & white, sepia, or sepia with tinted color panel images in a matter of minutes.

Hot Marketing Idea. Vicki creates image displays in local doctors' offices and retail stores, creating mini galleries all across her community. Her studio even orders full-color cards and flyers to market her work in smaller establishments.

Vicki and Jed Taufer
V Gallery
Morton, Illinois
www.vgallery.net

Vicki and Jed Taufer started V Gallery in the basement of their home over six years ago. Within a year, they had a 3500-square-foot photography studio on Main Street with six employees. Vicki has been featured in *Professional Photographer* and *Rangefinder* magazines. In 2006, Vicki received her Certification, and Master and Craftsman degrees from the Professional Photographers of America. She is also an official speaker for Kodak. Within the past year, Vicki has spoken to photographers across the United States and in Korea, the Philippines, and Italy. In 2005, she had the highest-scoring print at Orvieto Fotografia and the Grand Award at WPPI.

V Gallery is a Mac-based studio. Jed uses a PowerMac G5 with 3GB of RAM for his artwork. They also use PowerMac G4 computers with 19- and 22-inch monitors. As for digital capture, Vicki uses the Canon 1Ds. For the majority of her work, she uses a Canon 70–200mm f/2.8 lens. The camera rooms are equipped with Photogenic 1250 lighting equipment and Larson softboxes. Vicki also loves shooting with natural light and reflectors.

Advantages. One of the things Vicki loves most about today's technology is being able to maximize the creativity in her images.

Tantalizing Tips. Vicki believes customer service is vital to a successful business. In this age of impersonal service and instant everything, Vicki gives clients a whole other experience. Vicki finds that her clients appreciate being made to feel important and special; the way her business has grown so fast confirms that her approach is effective. She even sends handwritten thank-you cards to every client whom she photographs, just to show her appreciation for their business.

Popular Products. V Gallery offers the Bebé Collection to parents of newborns. This package can be purchased at a set price and includes three portrait sessions with a V Gallery Limited Edition session photographer, one easel, three matted 5x5-inch portraits from each session, $10.00 off any 8x8-inch desk art frame (which holds a matted 5x5-inch portrait), and 10 percent off birth announcements.

Hot Marketing Idea. Internet marketing is the latest method used at V Gallery for getting the word out about the studio. If Vicki wants to advertise new specials quickly, she sends e-mail announcements to her clients. For example, if she has too many frames on hand, she can offer a one-day sale and decrease the inventory immediately. Vicki plans to do more Internet advertising in the future.

Photo by Vicki and Jed Taufer.

Jennifer George
J Walker Photography
www.jwalkerphotography.com
San Diego, California

Jennifer George is a Master Photographer and Craftsman who lives in San Diego, California. She is a member of the Professional Photographers of San Diego County and in 1999, her first year entering print competition, she was awarded portrait photographer of the year. Her credits include: Professional Photographers of San Diego County's 2000 Illustrative Photographer of the Year, 2001 California Photographer of the Year and People's Choice Award (PPA California), and the 2003 Grand Premiere and First Place Award (WPPI). She has also received the 2004 Family Photographer of the Year and the People's Choice Award, 2005 Photographer of the Year Gold Level Award, and 2006 Non-Wedding Album of the Year, all from PPA.

Digital History. Digital capture has allowed Jennifer to be more creative with her image making and has decreased the time it takes to process the

Photo by Jennifer George.

work. With the added flexibility during shooting and the decrease in her workload, Jennifer says she is finding a renewed passion for photography!

Tantalizing Tips. Jennifer suggests using business displays to build your identity in the community. She photographs the business owner's children in trade for permission to place three 16x20-inch wall portraits in their business establishment.

Popular Products. Jennifer's Day in the Life albums are the hottest product in her studio. "For families with young children, it is a remarkable thing to follow them around and capture those precious moments in everyday life," Jennifer exclaims. The second hottest product in her studio is the "About" book. She captures a child or young adult and interviews them to create an album containing their words and portraits.

Hot Marketing Ideas. Jennifer creates custom business cards that feature her client's children, and she hands them to her clients when they pick up their images. She's found that, with portraits of the client's kids on the cards, clients are eager to hand them out to friends and family. What a great way to spread the word about your studio!

Process Review

PRE-SESSION

1. Consult with your clients regarding wardrobe considerations. Schedule the proofing consultation, and have them sign a contract and a model release form.
2. Sign the client up for the Day in the Life portrait session or the Treasured Moments multiple montage session. Complete the contract and review policies and procedures.

DAY OF THE SESSION

1. Conduct session.
2. Download images to main computer.
3. Immediately prepare a backup file, storing images on a server tape, a portable FireWire drive, CD, or DVD).

The more streamlined your workflow, the more time you can devote to creating extraordinary images. Photo by Vicki Popwell.

4. Copy images into the client's folder: edit and number images, but do not rotate. These are the original files and should not be touched until the images have been ordered.
5. Copy the numbered images into the client's work folder. (These files will be used for proofing.)
6. Rotate, crop, and color correct the image files as desired for proofs.

POST-SESSION

Stage 1

1. Fill out the Image Modification form (see page 93), make subtle or dramatic image enhancements, and prepare the proofs.
2. Burn a CD/DVD of the modified images.
3. Place orders for any images that will be presented to vendors as stock images.
4. Send the client an e-mail and follow up with a telephone call to remind them of their upcoming proofing consultation.
5. After the client has viewed their images and placed an order, activate the Internet viewing of proofs (for thirty days).

Stage 2

1. Copy images into the file prep folder, then make color corrections.
2. Pull out your order form and, using a color-coding system, highlight the various image sizes your client has ordered (e.g., highlight all 8x10-inch print orders in pink, all 4x6-inch prints in yellow, etc.).
3. With this accomplished, prepare subfolders for the various images sizes that the client has ordered.
4. Next, copy the images into the corresponding subfolders in order to properly fill your client's order (e.g., copy the image called Johnson005 into the 8x10-inch and 4x6-inch print folders, as the client would like this particular image in these sizes).
5. Retouch then crop the images. Change the file to a vertical orientation and change the file format to TIFF if required by your printer.
6. Burn a CD/DVD for the lab and send out the order.

Keep careful track of any image modifications that are done on your portraits so that if a client reorders an image down the line, the reprinted portrait will match their original purchase. Photo by Craig Minielly.

7. After placing the order, contact the lab to ensure that all of the files are acceptable, then delete the images from your hard drive.
8. Begin working on digital album design templates for pending orders.

Stage 3

1. Verify that the numbering on the lab's prints matches the numbers used on the corresponding proofs.
2. Cut and organize prints.
3. Place orders in gift boxes and call for pickup.
4. Insert mats and images in the album, if applicable.
5. Inspect and deliver!

APPENDIX 2

Education

There are many resources available to help you work through any trials you may encounter on your road to transitioning to digital capture. National organizations, publications, and seminars are invaluable when you are starting out. After all, when you join a community/business organization or professional association, you can meet people and get career guidance too.

ORGANIZATIONS

Professional Photographers of America
www.ppa-world.org
800-786-6277

National Association of Photoshop Professionals
www.photoshopuser.com
727-738-2728

Wedding and Portrait Photographers International
www.wppinow.com
310-451-0090

MAGAZINES

Digital Imaging
Cygnus Business Media
920-563-1769

Inside Photoshop
Element K Journals
800-223-8720

Photoshop User
National Association of Photoshop Professionals
727-738-2728

Professional Photographer
Professional Photographers of America
404-522-8600

Rangefinder
Rangefinder Publishing Company
310-451-8506

Studio Photography & Design
A Cygnus Publication
920-563-1769

ONLINE GROUPS

Online groups may also be a good source of information regarding digital imaging trends and technologies. Those we have found most helpful are:

Rob Galbraith Digital Photography Insights
(news, reviews, tutorials, forums)
www.robgalbraith.com

Digital Photography Review
(reviews, forums, glossary, newsletter)
www.dpreview.com

Be sure to learn as much as you can about the technological advances and artistic trends. Your clients will reap the benefits of your education, and your profits will increase, too! Photo by Joann Muñoz.

SEMINARS AND CONVENTIONS

By reading newsletters and e-mails from national photographic organizations, you should be able to identify upcoming educational seminars that may help you through the digital transition. Attend as many of these programs as you can until you get comfortable with your digital systems and processes. Also consider finding a mentor in the industry. It may be someone who has an established business, a Master Photographer, or a Photoshop guru. A mentor can educate you by example and can also give you pointers on making the digital transition. Learn from their experience and success.

WEBSITES

Websites are a great educational resource and a great place to turn to for inspiration. The following sites feature a wide range of information on digital photography, software, and other aspects related to digital imaging.

www.pdnonline.com
www.usa.canon.com/dlc
www.dpreview.com
http://photography-on-the.net
www.digg.com
www.lynda.com

Index